PROMOTE TOLERATE BAN

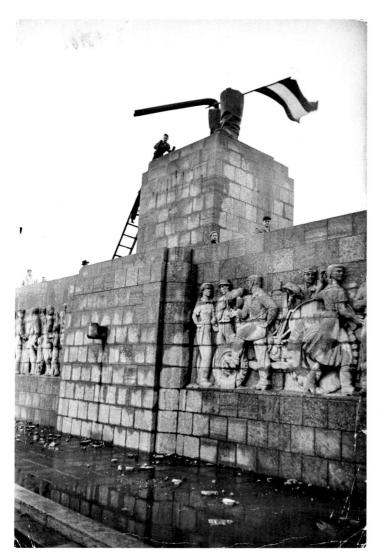

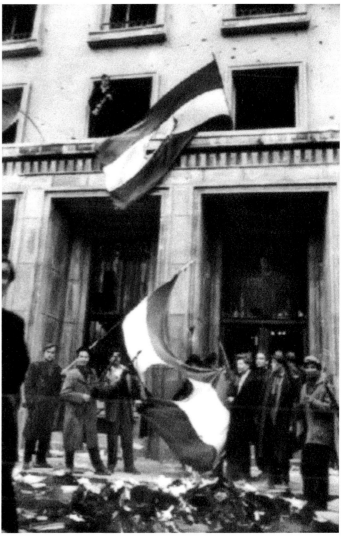

intellectuals and workers; soon thereafter, the military sided with the demonstrators and the uprising unfolded.

In the early stages of the uprising, the most symbolic act was the demolition of Sándor Mikus's colossal sculpture of Stalin, which had been erected in Budapest near Heroes' Square (Hősök tere) in 1951 as a tribute to Stalin's seventieth birthday. Within hours of attacking the statue, the crowd of protestors had left only the boots standing on the imposing pedestal — creating an iconic emblem of the uprising (fig. 1). Pieces of the dismembered statue were dragged throughout the city and further vandalized until they disappeared from public view. Formidable even in a deformed state, each fragment had a different fate. The right hand was rescued by the actor Sándor Pécsi; it was buried in his garden after his death in 1977 and not unearthed until 1986.[1] The utmost minimalist scrap of the sculpture is a three-inch-long nut and bolt.[2] Treated as a relic, the nut and bolt were mounted anonymously onto a wooden placard and engraved with the laconic inscription "Sztálin 1956 október 30." This transformation of the commanding eight-meter-tall statue to its smallest structural component, all of its monumental and anthropomorphic features lost, survives as a powerful remnant of the historical and conceptual shift experienced by Hungarians in their struggle against the terror of the Rákosi-Stalin regime.

On 30 October 1956, the Communist Party headquarters in Republic Square (Köztársaság tér) was targeted by the rebels searching for political prisoners allegedly held there.[3] The state security police who had been posted to guard the building were forced to evacuate, at which point they were showered with bullets. Most of those hit by the gunfire were killed. One victim was brutally lynched; his body was then desecrated by an angry mob. As this explosive turmoil erupted out of control in the square, freedom-fighting rebels hoisted from the front entrance of the building an altered Hungarian flag with the Rákosi regime's emblem cut out from the center of the tricolor, which became a revolutionary symbol during the uprising (fig. 2).

Western photojournalists such as Mario De Biasi, Erich Lessing, and John Sadovy began filing news reports and photographs showing the violence in Republic Square. Their work spread worldwide, generating such prominent headlines as "Patriots Strike Ferocious Blows at a Tyranny," in *Life* magazine.[4] The world was suddenly watching this small country in Central Europe revolt against Soviet political and military control. As the revolution took hold, a new government coalition formed under Imre Nagy. However, without support from the West, the country could not withstand the strength of the Soviets, and after twelve days of independence, the revolt was crushed by the return of Soviet forces on 4 November. Nagy, the recently appointed premier, sought protection in the Yugoslavian embassy while István Bibó, the new minister of state, remained in the Parliament. As the tanks rolled back into Budapest, Bibó delivered a historic public address declaring the legitimacy of the uprising and the newly formed Hungarian government:

> Irrespective of class or creed, the entire Hungarian people took part in the struggle and it was both astonishing and uplifting to see the humane and wise conduct, the ability to distinguish, of the people who had risen up, turning only against foreign oppressors and their henchmen.[5]

He further called on the Hungarians to disregard "the invading army and the puppet government it might set up...and [to] deploy the weapon of passive resistance against it."[6]

In the power struggle that ensued, Bibó was arrested and imprisoned, while Nagy was deported to Romania. Two years later, Nagy was secretly returned to Budapest, where he was tried for treason, executed by hanging, and buried in an unmarked grave. János Kádár, a former political prisoner under Rákosi, emerged as the new general secretary of the Hungarian Socialist Workers' Party (Magyar Szocialista Munkáspárt, or MSZMP) and the premier of the People's Republic of Hungary.

Crush of the Revolution — Purges and Executions

The first priority of Kádár's new government was to uproot the seeds of any revolutionary spark. While counting the casualties, including all fighters and civilians, the government ran an extensive investigative campaign to collect evidence, arrest, and press charges against anyone who was believed to have been involved in the uprising. Press photographs published by the Western media (such as *Life, Paris Match,* and *Epoca*) were used by the Hungarian state security police to identify and incriminate rebels. Approximately 230 were tried and executed as militants, while thousands were imprisoned for up to ten years. In 1963, Bibó, who received a life sentence, was released in the general amnesty granted by Kádár. However, he was forbidden from publishing and speaking in public.

Reframing the Counterrevolution

For over a decade, the Kádár propaganda machine used these same press images to recast the uprising in the mold of the Communist revolutionary rhetoric. The photographs were used in official reports published by the information bureaus of Moscow and Budapest to denounce the attacks and lynching in Republic Square as reminiscent of the fascist assassinations that had occurred in 1919. In that year, the short-lived Hungarian Soviet Republic, led by Hungarian Communist leader Béla Kun, was violently crushed by anti-Communist forces. To strengthen this rhetoric, the state agents executed by the freedom fighters were relabeled as defenders of democracy.[7]

Based on these photographs, narrative topoi were formulated to denounce the fascist character of the uprising, including the desecration of Soviet symbols, the burning of books on Communism and portraits of Communist leader Mátyás Rákosi, the massacre at Republic Square, and the Western aid to the revolutionaries. The official reports directed personal attacks against Nagy, demonizing him as the primary instigator of what was termed a counterrevolution. Books that continued to enforce this narrative were published and distributed from 1957 to 1986,[8] while similar interpretations of the 1956 uprising percolated into the social fabric of Hungary through public exhibitions, school textbooks, the mass media, and public art projects.

Art of the Counterrevolution

Monuments and artworks were commissioned through the end of the 1970s to promote the government version of events. In commemoration of the state security police killed by the counterrevolutionaries, Viktor Kalló's monument depicting a human figure falling to his knees with arms raised toward the sky was erected in Republic Square in 1960 and dedicated to the "Martyrs of the Revolution."[9] The official news media publicly praised and celebrated the police as heroes, turning the ones who had survived into national media stars.[10]

The printmaker Zoltán Váli, a Communist who had fought in the Spanish Civil War,[11] drew from the press images that had been reframed in the Hungarian white books to present the pervasive counterrevolution narrative and its motifs. Váli produced a commemorative portfolio of seventeen linocut prints directly inspired by the propaganda iconography (fig. 3). The book burning on the title page recalls the fascist actions carried out by the Nazis in the 1930s.

Another example of counterrevolutionary art is Lóránt Nyáry's portfolio of thirteen etchings, titled *Árnyékban* (1958; In the shadow). These provocative images combine Daumier-style social critique with Francisco Goya's *Disasters of War* (1810–20) to denounce the fascist nature of the counterrevolution and its impact on the People's Republic of Hungary. The work was supported by the Fine Art Foundation and had an introductory text by Gábor Pogány, an art critic who was later appointed director of the Hungarian National Gallery (Magyar Nemzeti Galéria). The copy of this work at The Wende Museum was dedicated to "comrade Sandor Harmat" as "an award for successful work," demonstrating the politicized use of the revolutionary events.

The holdings of The Wende Museum of the Cold War and the Michael and Carol Simon Collection of Hungarian Photography at the Getty Research Institute (GRI), along with historical archives in Budapest and interviews with artists who lived through the period, articulate a deeper understanding of the reception of the Hungarian Uprising

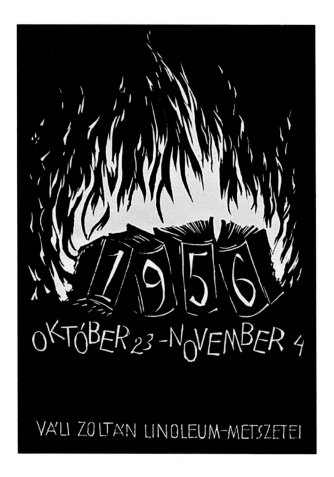

as it unfolded and was perceived over time. It is notable that the items in The Wende Museum collections referencing 1956 are mostly framed within the counterrevolutionary narrative. Equally remarkable is the lack of visual references to 1956 in the GRI collection, which spans over one hundred years of Hungarian photographic history. The collection was compiled by Michael Simon, one of the two hundred thousand émigrés to leave his homeland as a result of the demise of the uprising.[12] The single exception to this amnesia of 1956 in the Simon archive is the carbon copy of a 1977 letter written by Simon to the Hungarian Institute of Cultural Relations. Simon, by then an associate professor of photography at Beloit College in Wisconsin, needed to secure official government permission to spend extended periods of time in Hungary for his research. He wrote that he had been informed by the International Research and Exchange Board in New York that his "being a Hungarian who left in 1956 made his acceptance as a visiting scholar unlikely."[13] Although he was ultimately granted permission to travel to and carry out his research in Hungary, this statement demonstrates that even twenty years after the uprising, a Hungarian '56 émigré could be denied entry into Hungary.

Amnesia

During the Kádár era (1956–88), showing or simply owning photographs of the uprising was dangerous. It was particularly true in the first months after the revolution, when state security carried out a massive hunt for anyone involved in the recent fighting.

If caught in private hands, photographs or film footage were confiscated and used as incriminating evidence against their owners or other Hungarians who could be identified in the images. Following the revolution, even the photographs of the Hungarian news

FIG. 3.
Zoltán Váli (Hungarian, 1910–94).
1956 Október 23–November 4, 1957, linocut,
41 × 34 cm.
Culver City, The Wende Museum of the Cold War.

press agency MTI (Magyar Távirati Iroda) were seized by the Ministry of Interior and analyzed as evidence to press charges against individuals who could be identified through them.[14] This intimidation tactic silenced photographers and filmmakers (amateur and professional), and for over three decades, the uprising could not be talked about openly. It was not until the late 1980s, with the ending of the Kádár regime, that visual representations of the uprising (photographs, paintings, and drawings) began to emerge from the underground, and Hungarians were finally able to discuss the events of 1956 freely.

The exhibition *'56 Codes/Signals/Images: The Secret Art of the Revolution of 1956* (*'56 Rejt, Jel, Képek: A forradalom titkos művészete 1956*), mounted in 2016 at the Hungarian National Museum (Magyar Nemzeti Múzeum) to mark the sixtieth anniversary of the uprising, presented numerous stories of artists who hid their works out of fear. The painter István Görgényi created over sixty canvases conveying his experience of the revolution. He so feared retaliation that he covered the paintings with landscapes and still lifes and hid them in a cellar for decades. The emotional original images were unexpectedly discovered under the superficial paint in 2005 by a conservator.[15]

The conceptual artist László Haris was only thirteen years old when he photographed Republic Square a few days after the siege. He was so afraid of repercussions for having taken the photographs that he hid them and eventually destroyed the negatives. Fortuitously, a set of his prints survived and emerged in the 1990s.[16]

The Hungarian image bank Fortepan, which collects donations of twentieth-century photographs, recently posted online — without attribution or provenance — a group of photographs from 1956 that were found in an attic, where they had been hidden and abandoned for over six decades.[17]

Additionally, official censorship channels vigilantly scrutinized the contents of publications and exhibitions. In 1977, the photographer Péter Korniss was challenged for attempting to exhibit a folklore portrait showing a nativity shepherd wearing a small red, green, and white ribbon on his hat. He was chided for featuring this political symbol in his photograph and was advised to retouch it to mask its nationalist reference. According to Korniss, the photograph was exhibited without incident.[18] The polemic surrounding Korniss's image, however, is indicative of strict control over information and the use of political symbols.

The regime maintained an active network of secret agents and informants that had infiltrated both the public and private spheres. They were particularly suspicious of young emerging artists, who had created a network of contacts throughout the international art community. Numerous stories of encounters with the authorities and the secret police came from György Galántai, the founder of the Chapel Studio in Balatonboglár, an experimental avant-garde program that was eventually labeled illegal and shut down.[19] In one somewhat ludicrous story, the authorities counted the artists listed on the poster for the 1973 visual poetry exhibition *Szövegek/Texts,* curated by Dóra Maurer, to make sure there weren't exactly fifty-six names, which would have been considered an act of conspiracy against the state.[20]

Samizdat

Multiple cases of censorship and forced closings of exhibitions throughout the seventies and eighties are documented in the archives of Artpool.[21] By the early 1980s, the political opposition developed a network of underground literature (called *samizdat,* from

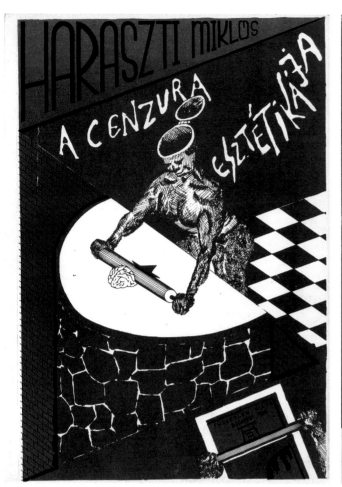

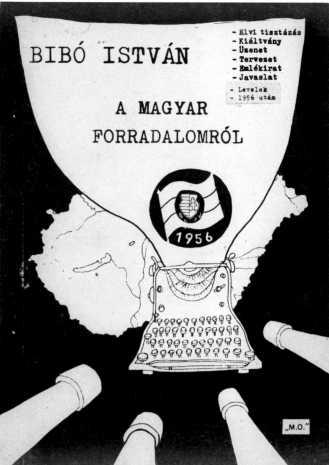

the Russian for "self-published") to address the controversial topics that did not meet the approval of official publishers. Samizdat became available in places such as Rajk's Boutique (Rajk Butik), the personal apartment of dissident artist László Rajk Jr. (the son of the executed foreign minister), who operated as a distributor for samizdat materials from 1981 until he was forced to close down in 1983. Rajk designed covers for the extensive inventory of samizdat produced by the independent publisher AB Független Kiado, including Hungarian translations of George Orwell's novels, which were banned in Hungary. Other banned titles included Miklós Haraszti's *A cenzúra esztétikája* (1986), translated in 1987 into English as *The Velvet Prison,* which described the position of artists in a totalitarian state. Rajk designed the cover of Haraszti's book to illustrate the vital role of samizdat literature (fig. 4). The center of the cover image is dominated by a figure, whose head is an empty container, standing at a counter and flattening his brain with a rolling pin. The brain becomes a red star to symbolize how individual creativity is being transformed by state ideology. This state-sponsored production process is contrasted by another rolling pin on the right lower corner outputting the work of the AB Független Kiado. Rajk heightens the image's underlying message with red and black constructivist spaces to resonate with the early Russian avant-garde aesthetic. In the early eighties, other samizdat publications, such as the series *Magyar Október* (Hungarian October), founded by György Krassó, framed the events of 1956 as a revolution and discussed István Bibó's writings in *A Magyar Forradalomról*.[22] Bibó's public address to the nation on 4 November 1956 was among the texts printed in this publication (fig. 5).[23]

FIG. 4.
Miklós Haraszti (Hungarian, b. 1945), author;
László Rajk (Hungarian, b. 1945), cover design.
A cenzúra esztétikája (Budapest: AB Független Kiado, 1986), cover.
Los Angeles, Getty Research Institute.

FIG. 5.
István Bibó (Hungarian, 1911–79), texts;
Ágnes Háy (Hungarian, b. 1952), cover design.
A Magyar Forradalomról (Budapest: Magyar Október, 1984): cover.
Los Angeles, Getty Research Institute.

Inconnu

The forced amnesia of the revolution was most evident in 1986, its thirtieth anniversary. On 14 August 1986, the dissident political group Inconnu published in the *New York Review of Books* an international call for art for an exhibition titled *The Fighting City (A harcoló város)*, to be held in a private apartment in Budapest.[24] The announcement provided a Budapest address for submitting the artworks and recommended that any related correspondence be sent to György Krassó in London. These instructions were devised to circumvent the surveillance system that was controlling Hungarian mail delivery. About forty works of art were received in Budapest and immediately confiscated. Nevertheless, the exhibition opened in the private apartment of Inconnu member Tibor Philipp. On display was documentation of the art that had been confiscated and the receipts from the state police. Using the files of the State Security Archives, historian György Sumegi completed in 2011 what he called the "last act of an exhibition": publishing the photographs of the artworks that had been confiscated, copied, and eventually destroyed in 1989 by the police.[25] That the artworks about the uprising were destroyed in 1989 attests to the rigidity of a regime that could not spare any tolerance on this topic, even at the end of the Cold War. The archive of Tibor Philipp contains a handmade catalog of the exhibition with scaled-down Xeroxed copies of the artworks mounted on the recto of each spread.[26] Among the artworks are the drawings of Ágnes Háy, an animation artist and expatriate who entered the avant-garde circles in the early seventies.[27] Inspired by the most popular press photographs that had circulated internationally, Háy submitted eight artworks that resonated with the revolutionary narrative. With her characteristic smooth line drawing mimicking the tracing of photographs, yet dynamically changing their original perspective, Háy captured the nationalistic moments of the attack, including the occupation of the Communist Party building, where she highlighted the front entrance and the fighters on the ground hoisting a big flag with the symbolic cut-out hole (fig. 6). This image is juxtaposed with a view of the vandalization of the dismembered head from the Stalin

FIG. 6.
Ágnes Háy (Hungarian, b. 1950).
Republic Square on 30 October 1956 (left); vandalization of Stalin's colossal statue (right), line drawings after press photographs, 1987, Xerox copies and mounting by the Inconnu group. From *A harcoló város kiállítás 1956–1986 = The Fighting City Budapest Exhibition* (Budapest: ca. 1987), n.p.
Budapest, Central European University.
Vera and Donald Blinken Open Society Archives.

sculpture. Her line drawings are based on press photographs taken by Erich Lessing, a Magnum photojournalist from Austria, and Jean-Francois Tourtet, from France, both of whom worked on assignment in Budapest.[28]

Although the provocative Inconnu exhibition about the revolution was shut down, even in the late 1980s, it did succeed in drawing international attention to censorship in the countries of the Eastern bloc. Yet precisely at this time, in the midst of Mikhail Gorbachev's glasnost policy, the Hungarian Socialist government system began to wind down, and history was soon to be rewritten.

Imre Nagy Reburial

In 1988, an ailing János Kádár stepped down, and a year later, the Committee for Historical Justice was formed to reassess the show trials of those executed in 1956 by the Kádár regime.[29] The committee organized the official reburial of Imre Nagy and the other victims of Kádár's purges in a state funeral in Heroes' Square, in front of Műcsarnok, a Hungarian contemporary art museum. The set, with the facade of the building draped in white, was designed by Gabor Bachman and László Rajk Jr. It evoked the constructivist architectural elements of the early Soviet avant-garde and included the symbolic hole of the revolutionary-altered flag, now an official icon of the Hungarian Uprising.[30]

Michael Simon was watching the historic event on American television when he recognized his friend, the photographer Péter Korniss, in the press corps. A month later, Simon was prompted to write an emotional letter to Korniss:

> Next day I watched you on the television screen as you photographed the Nagy funeral. I was much shaken by the event as it brought thirty-three years of memory full circle. Fortunately your friendly face appeared repeatedly on the screen and brought a touch of personal warmth to the solemnity of the event....
>
> I made a few exposures of the television screen thinking of the single image that should sum up the totality of the experience but I am afraid that the totality should be extremely difficult to sum up. There we were watching the greatest shock of our youth being set into a context,...where it became manageable and understandable. Even here, where '56 was always a revolution, the duality of thinking about that event remained confusing. Now we may think and feel about Nagy and '56 without this constant duality.[31]

Simon's sentimental reaction to the reburial of Nagy encompasses the experience of an entire generation who had seen history rewritten over and over again.

The Bibó Reader

The final chapter of this story of forgetting and remembering is the release in 2001 of the film *A Bibó Reader* by multimedia artist Péter Forgács. Forgács began his artistic career in the experimental filmmaking hub of Balázs Béla Stúdió. During the 1970s, Forgács built an archive of home movies collected from Hungarian families who documented their private lives with a video camera. The people seen in this footage belong to an increasingly remote past; they no longer exist beyond their lively personas acting in front of a friendly camera. They speak to new generations of viewers about a bygone era and their experience of history. Weaving this spontaneous prime material with historical newsreels and archival

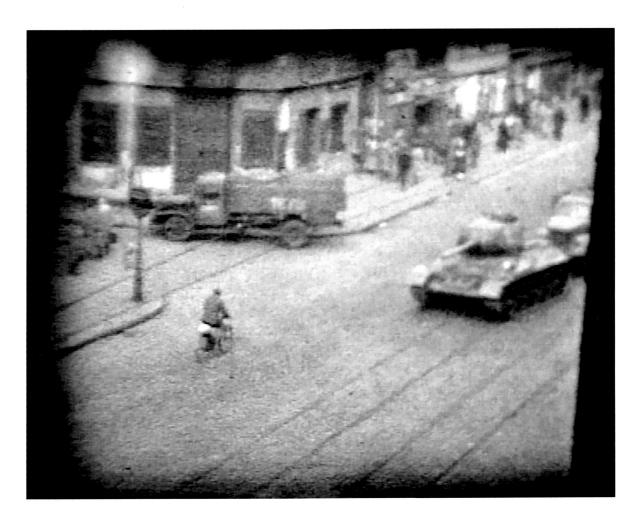

sources, Forgács performed his "alchemical" art, adding a vibrant voice to movies originally meant for private viewing in a distant past. In the case of *A Bibó Reader,* Forgács combined home movies made by Bibó's brother-in-law, László Ravasz Jr., with footage of the rubble of the uprising. Forgács composed a story of topics discussed by Bibó in his writings and in an interview that Bibó granted secretly in Budapest in 1979 before he died.[32]

Forgács gives a new voice to Bibó's core topics, examining his views of the foundational values of democracy, tolerance, and religious freedom.[33] The historical footage showing Bibó in the private setting of his family is alternated with winter views of Budapest or daily life in the city, juxtaposing direct or unconventionally metaphorical correspondences between videos and texts in Forgács's characteristic innovative style.

A ten-minute segment on the 1956 uprising shows the dramatic advance of the Soviet tanks through the boulevards of Budapest, followed by shots of the city in ruins, the scarred walls of buildings, and cranes working to clear the rubble.[34] These scenes are accompanied by Bibó's recorded proclamation from the Parliament building on 4 November 1956. As seen in figure 7, a man rides a bicycle in the opposite direction of a convoy of Soviet tanks, creating a subtle analogy of Bibó (and his defenseless country) going against the invading army. Beginning with this scene, Bibó proclaims Hungary's longing to live "within the unified community of Eastern European peoples who want to live their lives in a society of freedom and truth."[35] Forgács's combination of historical footage and Bibó's spoken declarations create a message from the past that had been suppressed in an Orwellian way for over four decades.

FIG. 7.
Péter Forgács (Hungarian, b. 1950).
Soviet tanks enter Budapest, 4 November 1956.
Still from *A Bibó Reader,* 2001, 70 min. (this frame:
58:42), multimedia DVD.

Through the language of art, the generation who had lived with a "constant dual-ity" (as Michael Simon defined it) could finally come to new terms with the meaning of the uprising. After thirty years of fabricated history and forced amnesia, Hungarian artists such as Forgács could empower themselves to publish original archival sources, historical photographs, and film footage to rewrite and revalidate their national history. In so doing, they restored in their collective memory concepts such as freedom and truth that had been tarnished by a regime built on the rubble and the blood of the revolution.

The Soviet Tank Symbol

The Balázs Béla Stúdió—where Forgács and other significant artists of his generation (such as Gábor Bódy, Ágnes Háy, and Dóra Maurer and filmmakers Gyula Gazdag and Béla Tarr) trained in multimedia arts in the 1970s—was an exclusive center for experi-mentation. In this setting, artists could operate on a semiofficial level without touching upon forbidden topics that would be outright censored. Forgács's earliest works, includ-ing the first films of his *Private Hungary* series (which began in 1988), addressed neither the Kádár era nor the 1956 uprising. Rather, Forgács openly showed the lives of Hungarian families during the two World Wars who were directly or indirectly impacted by the Holo-caust (which in Hungary took six hundred thousand lives).

Under Kádár, the Red Army represented the liberators who ended German occu-pation, and the Russian tank became a public symbol of the Soviet military and political might in Hungary. The Soviets liberated Hungary from the Germans in World War II by winning the Battle of Debrecen, in East Hungary, near the national park of Hortobágy. In 1978, this site was memorialized by the erecting of a Soviet tank on a sloped-surface pedestal, positioned as though it were climbing forward. The highly acclaimed, innova-tive photographer Gábor Kerekes took a photograph of this monument the same year, as part of a series focusing on critical views of Hungary from the Communist era.[36] By controlling the image's exposure to enhance its contrast, which isolated the monument from its surroundings, and with few contextual details, the tank seems ready to launch into space or, perhaps, to unexpectedly fall off the cliff (fig. 8). Kerekes, with his full control of photographic processes and techniques, had developed a language expressing a subjective, sinister view of the world, that eleven years later, with the reburial of Imre Nagy, was about to end.[37] X

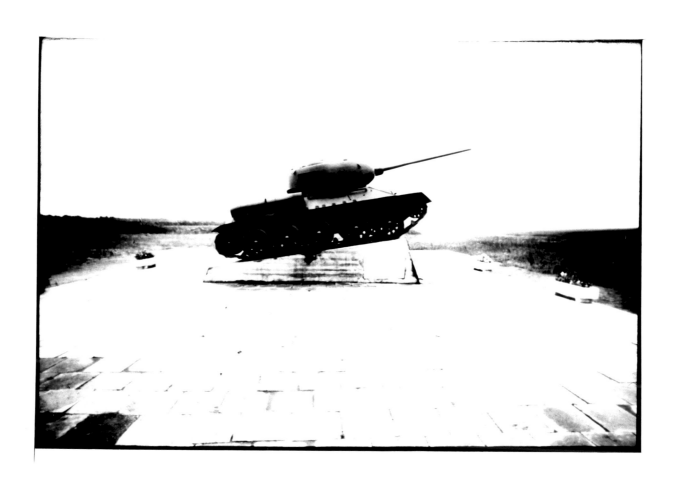

FIG. 8.
Gábor Kerekes (Hungarian, 1945–2014).
A tank monument to World War II (erected in 1978),
Hortobágy, 1978, gelatin silver print, 13.5 × 20 cm.
Los Angeles, Getty Research Institute.

NOTES

1 The hand, along with this story, was featured at the Hungarian National Museum (Magyar Nemzeti Múzeum) in the 2016 exhibition *Codes/Signals/Images: The Secret Art of the Revolution of 1956 (Rejt, Jel, Képek '56: A forradalom titkos művészete).*

2 This relic can be found at The Wende Museum of the Cold War (2012.1286.015), https://www .wendemuseum.org.

3 The same building hosted the Gestapo in the 1930s and 1940s.

4 Timothy Foote, "Patriots Strike Ferocious Blows at a Tyranny," *Life* 41, no. 20 (1956): 34–35.

5 Bibó's 1956 declaration was published posthumously with his collected writings: István Bibó, *The Art of Peacemaking: Selected Political Essays by István Bibó,* ed. Iván Zoltán Dénes, trans. Péter Pásztor (New Haven, CT: Yale University Press, 2015), 355–56.

6 Bibó, *The Art of Peacemaking,* 355–56.

7 Alexei Belokon' and Vladimir Tolstikov, *The Truth about Hungary: Facts and Eyewitness Accounts* (Moscow: Foreign Languages, 1957), plates between p. 64 and p. 65. For a discussion of these images, see Isotta Poggi, "The Photographic Memory and Impact of the Hungarian 1956 Uprising during the Cold War Era," *Getty Research Journal* 7 (2015).

8 See, for example, the English edition of the White Book, the official government report defining the regime version of the uprising as a fascist putsch: *The Counter-Revolutionary Forces in the October Events in Hungary* (Budapest: Information Bureau of the Council of Ministers of the Hungarian People's Republic, 1957); Ervin Hollós and Vera Lajtai, *Koztársaság Ter* (Budapest: Kossuth, 1974); and Ervin Hollós and Vera Lajtai, *Drámai napok, 1956 október 23–november 4* (Budapest: Kossuth, 1986).

9 Beverly A. James, *Imagining Postcommunism: Visual Narratives of Hungary's 1956 Revolution* (College Station: Texas A&M University Press, 2005), 67–81, https://www.wendemuseum.org.

10 István Rév, *Retroactive Justice: Prehistory of Post-Communism* (Stanford, CA: Stanford University Press, 2005), 246n5. The Hungarian National Museum (Magyar Nemzeti Múzeum) holds the press photographs that were used for these articles.

11 Zsigmondi Mária, "Beszélgetés Révai Deszővel," *Fotóművészet* 23, no. 2 (1980): 12. The works collected by the Wende can be seen at https://www.wendemuseum.org/collections /online-collections.

12 In 1956, Simon was a university student who took part in the Budapest demonstration on 23 October. In November, he joined the exodus from Hungary, following his mother, who had departed in early October.

13 The letter by Michael Simon is addressed to Maria Korosy, regional officer, Institute of Cultural Relations, Budapest, 14 February 1977, Michael and Carol Simon Collection of Hungarian Photography, 2011.M.8, box 23, folder 15, Getty Research Institute, Los Angeles.

14 I thank Katalin Bognár, Hungarian National Museum, for the discussion on the photography holdings acquired from the Ministry of Interior.

15 See *Codes/Signals/Images: The Secret Art of the Revolution of 1956,* exh. cat. (Budapest: Hungarian National Museum, 2016), 69.

16 Péter Baki, "15 előkerült fényhép," *Fotóművészet,* nos. 3–4 (2006): 81–90.

17 See Fortepan, http://www.fortepan.hu. I thank Andras Mink, Vera and Donald Blinken Open Society Archive, Budapest, for sharing this story with me.

18 Péter Korniss, interview with the author, 9 September 2016, Budapest. The exhibition *Korniss Péter fotó művész kiállítása* was held in the Budapest art museum Műcsarnok in 1974.

19 György Galántai, "Hogyan tudott a művészet az életben elkezdődni? Adalékok a boglári történethez," in *Törvénytelen avantgárd: Galántai György balatonboglári kápolnaműterme 1970–1973,* ed. Júlia Klaniczay and Edit Sasvári (Budapest: Artpool-Balassi, 2003), 43–90. The English translation, "How Art Could Begin as Life: Supplement to the Boglár Story," translated by Krisztina Sarkady-Hart, will be published by Artpool, http://www.artpool.hu, in 2017.

20 György Galántai, interview with the author, 9 September 2016, Budapest. For an illustration of the poster, see Artpool, http://www.artpool.hu/boglar/1973/730819p.html.

21 Exhibitions organized by Galántai, such as *Pacco dall'Italia,* in 1979, and *Hungary Can Be Yours,* in 1984, were banned because they touched on themes perceived as nationalist provocations.

22 György Krassó, a Hungarian political dissident and exile living in London, was sentenced to ten years in prison for his role in the 1956 uprising, but he was granted amnesty and released in 1963. Significantly, in the summer of 1989, Krassó founded the Hungarian October Party (in

direct reference to the 1956 uprising). Kristóf Nagy, "György Krassó—An Artistic Critique of Hungarian Regime Change (1989–1990)," paper presented at the Association of Art Historians conference, Norwich, England, April 9–11, 2015.

23 István Bibó, *The Art of Peacemaking,* 355–56.

24 The competition/exhibition announcement (to collect artworks) was issued by the *New York Review of Books,* 4 December 1986 (http://www.nybooks.com/articles/1986/12/04/announcement/). The outcome was published in "The Fighting City," *New York Review of Books,* 7 May 1987, http://www.nybooks.com/articles/1987/05/07/the-fighting-city/. The significance of this exhibition is analyzed by Juliane Debeusscher in "Information Crossings: On the Case of Inconnu's *The Fighting City,*" *Afterall: A Journal of Art, Context, and Enquiry,* no. 31 (2012): 71–83; and by Kristóf Nagy, "Aesthetic and Politics of Ressentiment—The Inconnu Group's Shift towards National Populism" (master's thesis, Central European University, 2016), 28–29.

25 See György Sümegi, "Egy kiállítás utolsó felvonása," Betekintő, http://www.betekinto.hu/2011_2_sumegi/.

26 *A harcoló város kiállítás 1956–1986 = The Fighting City Budapest Exhibition* (1987), The Open Society Archive, HU OSA 362, Tibor Philipp Personal Papers, Central European University, Budapest.

27 Háy left Hungary for London in 1985 with her partner, György Krassó.

28 The image on the right, showing the silhouette of the destruction and vandalization of Stalin's face, is based on the photograph in the special issue of *Life: Hungary's Fight for Freedom: A Special Report in Pictures* (New York, 1956), 6-7.

29 The state conceded to the request of the political opposition to form this committee (Történelmi Igazságtétel Bizottság, TIB).

30 David Crowley, "Staging for the End of History: Avant-Garde Visions at the Beginning and the End of Communism in Eastern Europe," Faktografia (blog), 14 April 2015, https://faktografia.com/2015/04/14/staging-for-the-end-of-history-avant-garde-visions-at-the-beginning-and-the-end-of-communism-in-eastern-europe/. Crowley provides further details about the symbolic use of the iconography.

31 Letter from Michael Simon to Péter Korniss, 5 July 1989, Michael and Carol Simon Collection of Hungarian photography, 2011.M.8, box 23, folder 3, Getty Research Institute, Los Angeles.

32 Catherine Portuges, "Found Images as Witness to Central European History: *A Bibó Reader* and *Miss Universe 1929,*" in *Cinema's Alchemist: The Films of Péter Forgács,* ed. Michael Renov and Bill Nichols (Minneapolis: University of Minnesota Press, 2011), 159–76.

33 These topics were the following: rule of law, human dignity, Hungarian public life, the peasant condition, ordinary people, romantic patriotism, the division of Hungary, public hysteria, public shock, the Christian middle class, Central and Eastern Europe, assimilation, the Jewish question, people's livelihoods, Christ, the persecuted, personal responsibility, democracy, the new anti-Semitism, 1956, and the Kádár regime. Péter Forgács, Tibor Szemző, György Budai, and László Ravasz, *A Bibó Reader* (Amsterdam: Mumen Film & Television, 2001), DVD, 69 min, sound, black and white.

34 The historical footage for the segment on the return of the Russian tanks and the views of the rubble of destroyed buildings in Budapest is the unique work of László Dudás, a filmmaker who secretly documented the immediate aftermath of the uprising and gave it directly to Péter Forgács. Péter Forgács, interview with the author, 15 September 2016, Budapest.

35 Péter Forgács, interview with the author, 15 September 2016, Budapest. See also Sven Spieker, "At the Center of Mitteleuropa, a Conversation with Peter Forgács," Art Margins, 21 May 2002, http://www.artmargins.com/index.php/interviews-sp-837925570/354-at-the-center-of-mitteleuropa-a-conversation-with-peter-forgacs/.

36 Zsolt Peter Barta, e-mail correspondence with the author, April 2017.

37 Wim Melis, Marco Wiegers, Marc Floor, D. H. Mader, and Václav Macek, *Behind Walls: Eastern Europe before and beyond 1989* (Groningen, Netherlands: Stichting Aurora Borealis, 2008), 49. In 2005, it was revealed that Gábor Kerekes played a role as an undercover informer during the Socialist era. Perhaps the ambiguity of this photograph can be read through this light as well. Colin Ford, Kincses Károly, and Marianna Kiscsatári, *Analogue: 21 Hungarian photographers from the 20th century, Körmendi-Csák Photography Collection* (Budapest: Liberty Art Centre, 2013), 250. I thank Zsolt Peter Barta for providing further information on this photograph through e-mail correspondence in April 2017.

Central Committee resolution in November that year. This campaign encouraged the populist movement and the populist Communist followers of the literary historian István Király to stir up their own campaign. They charged the leadership with neglecting national interests and traditions by tying these points to the dominance of "cosmopolitan" and "antinational" groups and to the allegedly corrupting effects of the NEM. These populist antireform campaigns had partly anti-Semitic undertones (which clearly targeted Minister of Culture György Aczél, who was Jewish). As the Kádár regime attempted to halt political and economic reforms, the regime's very legitimacy was questioned.[74] This crisis of legitimacy was further exacerbated by the very growth of the public sphere and the nascent, yet apparent, autonomy of the state from the party (see Cseh-Varga, this volume). [75]

As the historian Mária Heller pointed out, it is at this time that the "manual piloting"—the arbitrary, ad hoc interventions in the running of society initiated lower down in the bureaucracy—became increasingly inconsistent and hasty, resulting in the growing number of conflicts between central power and the intellectuals and progressive avant-garde artists. During the criminal trial of ultra-left writer and journalist Miklós Haraszti in October 1973, political tensions resulting from the lack of central authority and the retreat from reform reached its peak.[76] Haraszti had been arrested and put on trial for "incitement" due to circulating copies of his account of working in a tractor factory. The trial proved a fiasco; it helped unite all opponents of the regime. It even risked undermining Hungary's "relatively favorable international image."[77] In January 1974, Haraszti was given a suspended sentence and ordered to pay court costs. Kádár decided that such a trial should not be repeated, but that same year, the sociologists György Konrád and Iván Szelényi were arrested for writing their manuscript "The Intellectuals on the Road to Class Power" and later released. In 1970, avant-garde artist György Galántai made the most of a law, as part of the 3Ts, whereby studio exhibitions did not require a permit, and transformed a chapel in Balatonboglár, located outside of Budapest, into what was called the Chapel Studio (Balatonboglári Kápolnaműterem). In this private, autonomous building, artists collectively organized events and exhibitions. Paradoxically, the authorities closed Galántai's Chapel Studio in 1973 and appropriated the chapel. Herewith the alienation of the reformist left intelligentsia and the progressive avant-garde was complete.

The arbitrary interventions in the running of society irrespective of prior regulations or decisions had never really ceased. Progressive artists, the democratic opposition, and reformers experienced these arbitrary harassments in the form of house searches, revoked passports, loss of jobs, revocation of party membership, and the cancellation of exhibitions and filmmaking. A host of tolerated artists—including László Lakner, György Lőrinczy, Endre Tót, and even art critic Géza Perneczky—chose to leave Hungary during the first half of the 1970s, whether because their publications and exhibitions had been closed down or because they received a foreign scholarship which, if accepted, required leaving Hungary forever.

In 1975, a year after he had immigrated to Germany on a DAAD (Deutscher Akademischer Austauschdienst) scholarship, László Lakner exhibited a series of paintings at the Neue Galerie, Sammlung Ludwig, in 1975 in Aachen, Germany. The companion exhibition catalog—*László Lakner: Gesammelte Dokumente, 1960–1974*—included the reproduction of photos of Hungarian and Russian revolutionary workers, Lenin's telegram to the Hungarian Räterepublik in German (the language of the revolution at the time), a postcard with the image of seamstresses listening to Hitler, photos of the barricades of

the May 1968 uprising in Paris, index cards from the card catalog of the Budapest Ethnographic Museum (Néprajzi Múzeum), as well as newspaper clippings, philosophical quotes, and everyday objects, such as piles of red bell peppers, that Lakner used as the basis for his paintings for the exhibition. His paintings reproduced from images of these documents reflect on the past in relation to the present. Insightful for understanding his search for a leftist system-critical language, Lakner's collection of documents activate cultural memory and focus on questions about the "possible available relations to the (perpetually remade) [Hungarian] past."[78]

Mirage of Promise

Lenin considered revolution to extend to and embrace cultural aspects of society, which would ultimately improve general knowledge and Socialist consciousness. In the interest of highlighting and justifying Hungary's "revolutionary" Socialist construction, the Kádár regime—on the fiftieth anniversary of the 1919 Hungarian Commune—tied the Prague Spring in 1968 and the May events in France in 1969 to its own interpretation of the Hungarian Soviet Republic's history, one based on a narrative of continuous revolution and counterrevolution.[79]

Conversely, tolerated avant-garde artists understood cultural revolution in relation to the Prague Spring, international student movements, countercultures, and a new, emerging conception of political identity developed in the midst of these uprisings in the late 1960s. The most iconic images of revolution were the May events in France, transmitted in real time and before an international television audience.[80] These images created a dilemma: which revolutions were worth fighting for? For many, death had lost its significance in the wars in Algeria and Vietnam.[81] The revolution's "mirage of promise," which seemingly paved the way for truth-telling and reform, faded with the end of the long 1960s.[82] Nevertheless, the Hungarian avant-garde found inspiration from past and contemporary events.

The Hungarian avant-garde's "invisible war," to borrow Václav Hável's term, against the regime's notion of revolution in culture became apparent in their work, as transmitted through vernacular objects that they selectively assembled, interpreted, and re/presented.[83] Through the work of the avant-garde, Socialist realism was shown to be a convention marked by representational fluidity. More often than not, these artists' conceptual strategies captured the contradictions between the revolutionary promise of Socialism and the real, existing Socialism; between the artist's intentions and the public perception of a painting; and between a photograph's analytical and descriptive forms, which allowed it to narrate the experience of life lived rather than life recorded. Their art superseded the tautology of "being only what it is," allowing the contemporary viewer to credit them with critical interest and the ability to reach a superior level of symbolism. In the avant-garde's search for critical expression, it was photography—the nexus of painting and new media in post-1956 Hungary—that pushed furthest the definition of realism across artistic disciplines.

These kinds of documents allow us to reconstruct the avant-garde's critical position toward the political and social situation in Socialist Hungary. In August 1972, László Beke coordinated an action and exhibition with thirteen Hungarian and eleven Czechoslovakian artists to demonstrate that Hungarians had held onto their civic aspirations and desire for freedom (fig. 15). Together with the citizens' voices of discontent, the networks and artistic exchanges established with the West irrevocably expanded the

FIG. 15.
László Beke (Hungarian, b. 1944) et al.
Handshaking Action in Balatonboglár, Chapel Studio, 1972, gelatin silver prints, 54.5 × 40 cm.
Los Angeles, Getty Research Institute.

BALATONBOGLÁR 26-27. 8. 72.

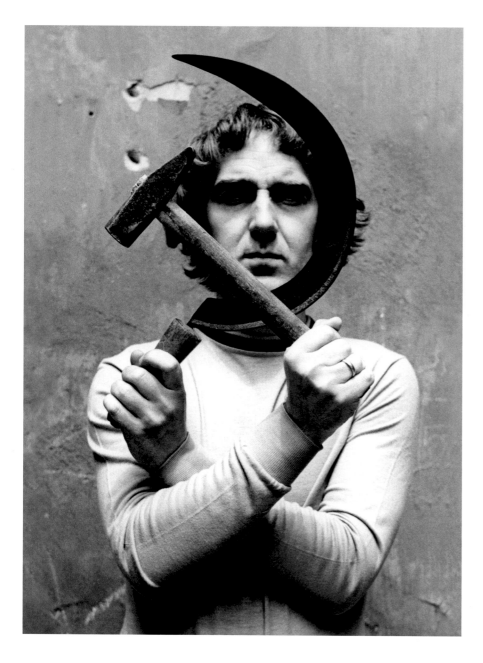

second public sphere (audience)—but they stood apart from other Socialist countries in how they achieved them.

In Pécs, an unmonitored urban space of experimental art located near the border with Croatia, Sándor Pinczehelyi initiated a more successful approach to conceptualizing culture. Beginning in 1972, he consistently reconstructed worn-out Communist symbols in different materials, and he played on historical, personal, and everyday meanings and uses to make the symbols ambiguous, as in the staged 1973 photograph *Sickle and Hammer I* (fig. 16).[84] Later in 1988, Pinczehelyi explored the roots of contemporary global culture by showing how symbols and signs generated by divergent consumer cultures converge in everyday life, as seen in his series of stenciled paintings, *Small Star, Coca Cola.* Created shortly before the fall of the Berlin wall, *Small Star, Coca Cola III* (1988) presages how Western consumer culture would contribute to the weakening of the Soviet stronghold over East-Central Europe and how the demands of the people would come to overpower the autocracy of the state (fig. 17).

FIG. 16.
Sándor Pinczehelyi (Hungarian, b. 1946).
Sickle and Hammer I, 1973, photograph,
25.4 x 20.2 cm.
Los Angeles, Getty Research Institute.
Photo by Katalin Nádor.

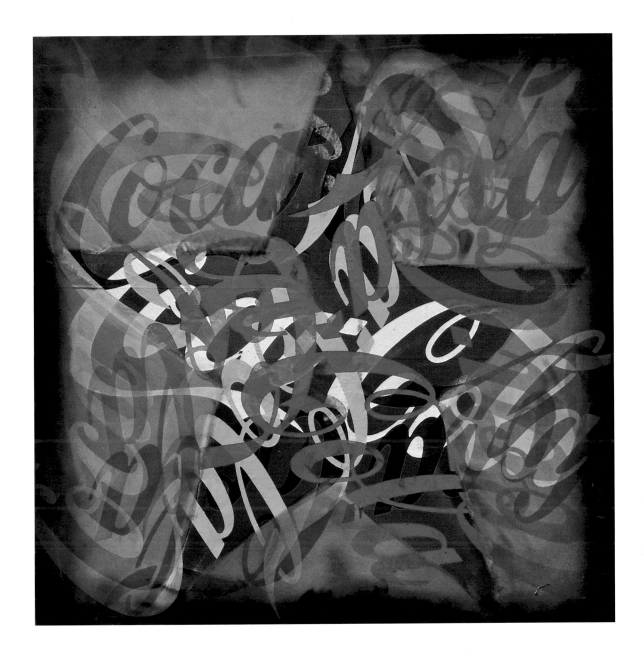

The powerful role that art played in shaping Cold War Hungary is represented in the comparison of this period of history with the universally popular puzzle the Rubik's Cube. At the height of the Cold War, Hungarian culture mediated between the state's framework of Socialist modernity and the progressive avant-garde's rejection of state-sanctioned art and design. In 1974, Ernő Rubik designed the Cube, which, for him, symbolized the human condition of his time.[85] As such, it represents the perfect conceptual model through which to understand the myriad strands that make up culture in Cold War Hungary. This puzzle captures the constant, almost inexplicable, oscillating relationships between central power and progressive artists and intellectuals, as well as the web of informal, personal, and advisory relations that expanded the public sphere. It exemplifies the relationship between artistic agency and different cultural spaces, where Socialist modern aesthetics and design, as expressed in paintings, photobooks, and posters, appeared to animate life. The Rubik's Cube stands as a symbol of how the intricately interdependent network of Cold War Hungary's Socialist modern and radical aesthetics are held together by one core mechanism—namely, its unique culture. **X**

NOTES

In this essay, the term *avant-garde* is used to indicate the artists who fluidly integrated modern art from the 1920s and 1930s with the new postwar tendencies produced in the spirit of progression and who took an "oppositional" stance in Hungary. I will therefore refer to the new trends in Cold War Hungary as avant-garde.

1 Central Europe seemed to disappear when it was incorporated into the Eastern bloc following World War II. The Soviet occupation had a tragic, neutralizing effect on the culture, society, and political and economic ambitions of the countries under communist rule. See Piotr Piotrowski, *In the Shadow of Yalta: Art and the Avant-Garde in Eastern Europe, 1945–1989* (Cornwall: Reaktion, 2009), 23. The label *Eastern bloc* designates the Soviet-controlled countries and colonies in Central and Eastern Europe (CEE). The CEE generally encompasses the Soviet Union and the seven Soviet satellite states of the Warsaw Pact (Albania, Bulgaria, Czechoslovakia, East Germany, Hungary, Poland, and Romania).

2 See the introduction in Klara Kemp-Welch, *Antipolitics in Central European Art: Reticence as Dissidence Under Post-Totalitarian Rule, 1956–1989* (London: I. B. Tauris, 2014), 2–11. The key intellectuals and theorists of Central European dissent are Václav Havel, György Konrád, and Jacek Kurón. Their writings are important for a historically specific understanding of autonomous social groups and unofficial initiatives, as well as the directions pursued by experimental artists in the region.

3 Ilya Ehrenburg's own metaphor and the title for his novel *Ottepel* (1954; *The Thaw*, 1955) gave the period its name. See Stephen V. Bittner, *The Many Lives of Khrushchev's Thaw: Experience and Memory in Moscow's Arabat* (Ithaca: Cornell University Press, 2008), 3.

4 François Furet, *The Passing of an Illusion: The Idea of Communism in the Twentieth Century* (Chicago: The University of Chicago Press, 1995), 209.

5 Socialism and Communism, based on public ownership of the means of production and centralized planning, both aimed to eliminate the inequality of wealth and the division of labor. Socialism had many variant strands that were reduced to Bolshevism—also known as Marxist-Leninism—which was the ideological basis for Communism.

6 Tony Judt, *Postwar: A History of Europe Since 1945* (New York: Penguin, 2005), 311.

7 See Susan Reid, "Socialist Realism Unbound: The Effect of International Encounters on Soviet Art Practice and Discourse in the Khrushchev Thaw," in *Socialist Realisms: Soviet Painting, 1920–1970*, ed. Matthew Cullerne Bown, Matteo Lafranconi, and Faina Balakhovskaid (Milan: Skira, 2012), 261.

8 Furet, *The Passing of an Illusion*, 464.

9 These fraternal Communist states were Albania, Bulgaria, East Germany, Hungary, Poland, Romania, China, Korea, Vietnam, and Mongolia.

10 Reid, "Socialist Realism Unbound," 264–65.

11 Krisztina Fehérváry, *Politics in Color and Concrete: Socialist Materialities and the Middle Class in Hungary* (Bloomington: Indiana University Press, 2013), 78–110, esp. 79.

12 See Fehérváry, *Politics in Color and Concrete*, 4–5.

13 Cultural and design historians have used the term *Socialist modernity* to describe material culture in Eastern Europe. See Susan Emily Reid and David Crowley, *Style and Socialism: Modernity and Material Culture in Post-War Eastern Europe* (Oxford: Berg, 2000); and Katherine Pence and Paul Betts, eds., *Socialist Modern: East German Everyday Culture and Politics* (Ann Arbor: University of Michigan Press, 2008).

14 Rudolf L. Tökés, *Hungary's Negotiated Revolution: Economic Reform, Social Change, and Political Succession, 1957–1990* (Cambridge: Cambridge University Press, 1996), 92–93.

15 *Hungary 1965* (*Magyarország 1965*) (Budapest: Gondolat Kiadót, 1965), n.p.

16 This was stated in the Tenth Party Congress Program of the Hungarian Socialist Workers' Party in 1970. See "Az MSZMP X. Kongresszusának határozata a part munkájról és a további feladatokról," in Henrik Vass, ed., *A Magyar Szocialista Munkáspárt határozatai és dokumentumai: 1967–1970* (Budapest: Kossuth Könyvkiadó, 1974), 705, as quoted in Beth Greene, "Socialist Popular Culture and Youth Culture during the Long 1960s in Hungary" (PhD diss., University of California, Los Angeles, 2013), 152.

17 Greene, "Socialist Popular Culture," 166. The NEM, launched in 1968, was pursued until around 1972. It aimed for a profitable and competitive economy through comprehensive economic reform.

18 Greene, "Socialist Popular Culture," 150.

19 One of the busts exhibited in the exhibition *Portraits of Lenin in Hungarian Sculpture* (*Lenin Alakja a Magyar Szobrás*) (Budapest, Hungarian National Gallery [Magyar Nemzeti Galéria], 25 April–24 May 1970) is now in the holdings of The Wende Museum of the Cold War in Culver City. Aladár Farkas, *Lenin Bust*, 1946, bronze, 37 × 25 cm, 2010.2013.014. http://wendemuseum.org/collections/online-collections. Socialist sculptors could not easily express their moral scruples by switching styles, as painters could. The highly respected neoclassical sculptor Pál Pátzay, along with the expressive-realist sculptors Kisfaludi Strobl and Jenő Kerényi, experienced continuous careers under the two Communist regimes in Hungary. See Géza Boros, "The Metamorphosis of Liberty: The Monument to Hungarian Liberation," in *Figuration/Abstraction: Strategies for Public Sculpture in Europe, 1945–1968*, ed. Charlotte Benton (Burlington, VT: Ashgate, 2004), 77, 71–74.

20 Roger Gough, *A Good Comrade: János Kádár, Communism, and Hungary* (London: I. B. Tauris, 2006), 112.

21 See James Aulich and Marta Sylvestrová, *Political Posters in Central and Eastern Europe, 1945–95: Signs of the Times* (Manchester: Manchester University Press, 1999), 31n28–29.

22 Aulich and Sylvestrová, *Political Posters*, 29. See also György Aczél, *Culture and Socialist Democracy* (Budapest: Corvina, 1975), 20–21.

23 Gough, *A Good Comrade*, 129.

24 Gough, *A Good Comrade*, 130.

25 See David Crowley, ed., *Design and Culture in Poland and Hungary*, 1890–1990 (Brighton: University of Brighton, 1992), 83–84.

26 David Crowley argued that "this strange form of collusion was, to appropriate Miklós Haraszti's phrase, a 'Velvet Prison' in which the antagonism between designers and the State that one might expect of a creative, intellectual profession did not occur—designers acted as both jailors and jailed." See Crowley, *Design and Culture in Poland and Hungary*, 81.

27 Laura J. Hoptman and László Beke, *Beyond Belief: Contemporary Art from East Central Europe* (Chicago: Museum of Contemporary Art, 1995), vi. This Lektoratus was juried by artists, art critics, and art historians.

28 Eszter Kiss, in conversation with the author, December 2015.

29 The journal, which is still in publication, welcomed the work of progressive artists for publication. It therefore was seen as an open forum for new experimental art.

30 Virág Molnár, "In Search of the Ideal Socialist Home in Post-Stalinist Hungary," *Journal of Design History* 23, no. 1 (2010): 60.

31 Mária Heller, Dénes Nemedí, and Agnes Rényi, "Structural Changes in the Hungarian Public Sphere under State Socialism," in *The Transition from State Socialism in Eastern Europe: The Case of Hungary*, ed. Adam E. Seligman (Greenwich, CT: JAI, 1994), 168.

32 As Piotr Piotrowski explained, "This understanding of culture had its roots in the history of Central Europe, in particular in the nineteenth century, when many national groups within the region were prevented from articulating their political aspirations freely and directly." Additionally, the progressive avant-garde considered abstract art the complete incarnation of the notion of modernity and a sign of participation in the world's advanced contemporary art. See Piotr Piotrowski, *In the Shadow of Yalta*, 67-68, 127.

33 Krisztina Fehérváry, "Goods and States: The Political Logic of State-Socialist Material Culture," *Comparative Studies in Society and History* 51, no. 2 (2009): 435. Paul Betts argued that Bauhaus design served as a compass for postwar design in East and West. See Paul Betts, *The Authority of Everyday Objects: A Cultural History of West German Industrial Design* (Berkeley: University of California Press, 2004), 17; and Virág Molnár has identified the influence of Le Corbusier's ideas in architecture. See Virág Eszter Molnár, *Building the State: Architecture, Politics, and State Formation in Post-War Central Europe* (London: Routledge, 2013), 79.

34 Svetlana Boym, "A Soviet Flower of Evil: Representation of Everyday Life in the Socialist Realist Art," in Matthew Bown and Matteo Lafranconi, *Socialist Realisms: Soviet Painting 1920–1970* (Milan: Skira, 2012), 191.

35 See Wolfgang Hütt, "Realism and Modernity," *Bildende Kunst* (October 1956): 565–67. This essay effectively summarized this polemical issue.

36 Endre Domanovszky, "Die Bildende Kunst Ungarns und der XX. Parteitag der KPDSU," *Bildende Kunst* (May 1957): 286.

37 Reid, "Socialist Realism Unbound," 269–72.

38 Reid, "Socialist Realism Unbound," 261.

39 Reid, "Socialist Realism Unbound," 269–72.

40 Kádár's Socialist-realist painting *Before the Storm* (*A vihar előtt*) was showcased at the Second Exhibition of Hungarian Art in 1951. See Gábor Pogány, *Hungarian Painting in the Twentieth Century* (Budapest: Corvina, 1960), 34.

41 The Hungarian art historian Gábor Rieder used the term *Socialist modern* to denote the "typical Socialist and modernist painting of the period of the Detente." See Gábor Rieder, "Szocreál és szocmodern: Fogalomzavar az ötvenes-hat-vanas évek hivatalos müvészetében," in *A zsarnokság szépsége. Tanulmányok a totalitarianismus müvészetéről*, ed. Gerda Széplaky (Pozsony: Kalligram, 2008), 75–87. Éva Körner's book *Derkovits Gyula* (Budapest: Corvina, 1968) was "on the borderline of what was still acceptable and what was regarded as avant-garde." See Éva Forgács, "Competing Narratives: Art Criticism and Art History of Modernist and Contemporary Art of the 1960s," *Centropa* 11 (2011): 12.

42 As quoted in Sándor Hornyik, "Aesthetics in the Shadow of Politics: Surnaturalism and Magical Socialist Realism in Hungary in the Early Sixties," *Acta Historiae Artium* 56 (2015): 326.

43 See Piotrowski, *In the Shadow of Yalta,* 127, 130.

44 Dávid Fehér, "Painted Reality: The Beginnings of Photorealism in Hungary," in Erőss Nikolett et al., *East of Eden: Photorealism: Versions of Reality* (Budapest: Ludwig Múseum—Kortárs Művészeti Múzeum, 2012), 22; and Éva Forgács, "1956 in Hungary and the Concept of East European Art," *Third Text* 20, issue 2 (2006): 183.

45 See Greene, "Socialist Popular Culture," 17.

46 See Crowley, *Design and Culture in Poland and Hungary,* 83–84.

47 Heller et al., "Structural Changes," 163.

48 Péter György and Hedvig Turai, *Art and Society in the Age of Stalin* (Budapest: Corvina, 1992), 22.

49 http://wendemuseum.org/collections/online-collections.

50 Fehérváry, *Politics in Color and Concrete,* 120.

51 Dean Duda, "Socialist Popular Culture as (Ambivalent) Modernity," in *Socialism and Modernity: Art, Culture, Politics, 1950–1974,* ed. Ljiljana Kolešnik (Zagreb: Museum of Contemporary Art and Institute of Art History, 2012), 259; and Dick Hebdige, *Hiding in the Light: On Images and Things* (London: Routledge, 1988), 47.

52 The popular, nonpartisan graphic designer Árpád Darvas is credited with introducing pop-art styles into poster design in Hungary. The primary sources of information about pop art in Budapest were the foreign-language bookstore, embassy libraries, and the library of the Fészek Artists' Club (Fészek Művészklub), which provided access to art-related literature, in particular Western art magazines, including *Art in America, Artforum,* and *Studio International,* among others. See Dávid Fehér, "Where Is the Light?: Transformations of Pop Art in Hungary," *International Pop,* ed. M. Darsie Alexander and Bartholomew Ryan, exh. cat. (Minneapolis: Walker Art Center, 2015), 140.

In the tolerated avant-garde art scene, information circulated through personal networks; for instance, the progressive artist Dóra Maurer, whose dual citizenship allowed her to travel frequently between Austria and Hungary, and who acted as a source of information for her fellow artists and colleagues.

In 1977, the American collector Jean Brown purchased a year's subscription to the international art magazine *Flash Art* for the Hungarian conceptualist artist Gábor Toth. See correspondence with Gabor Toth, 8 April 1977, Jean Brown archive, acc. no. AP2641/2016, Artpool Art Research Center, Budapest, Hungary.

Influential international shows were the Documenta exhibitions held in Kassel, Germany, from 1964 to 1972; the Venice Biennale in 1964, and the American pop-art exhibition in 1964 at Vienna's Museum of the 20th Century. See Fehér, "Where Is the Light?," 146; and Dávid Fehér, "Painted Reality: Beginnings of Photorealism in Hungary," in *Édentől keletre: Fotórealizmus: Valóságváltozatok = East of Eden: Photorealism: Versions of Reality,* ed. Nikolett Erőss (Budapest: Ludwig Múseum, Kortárs Művészeti Múzeum, 2012), 34.

53 Fehérváry, "Goods and States," 437.

54 Crowley, *Design and Culture in Poland and Hungary,* 81.

55 Tibor Hajas, *Öndivatbemutató* (1976), https://www.youtube.com/watch?v=CVOPjNmbzVg.

56 Éva Forgács, "Competing Narratives: Art Criticism and Art History of Modernist and Contemporary Hungarian Art of the 1960s," *Centropa* 11 (2011): 61; and Eva Forgács, "Kultur im Niemandsland: Die Stellung der ungarischen Avantgarde in der ungarischen Kultur," in *Die Zweite Öffentlichkeit: Kunst in Ungarn im 20. Jahrhundert,* ed. Hans Knoll (Dresden: Verlag der Kunst, 1999), 19

57 See Gyula Pauer, *Marx-Lenin,* Artpool, http://www.artpool.hu/lehetetlen/real-kiall/nevek/pauer_marxlenin.html.

58 Dávid Fehér, "(Dis)Figuring Reality: New Forms of Figuration in Hungarian Painting," paper presented at the international conference "Contested Spheres: Actually Existing Artworlds under Socialism," Translocal Institute and Kassák Museum Budapest, May 2016.

59 Similar to Moscow conceptualism, the Hungarian avant-garde owes its influence to the questions it posed about the connections between art, culture, and society.

60 Tim Benson, *Central European Avant-Gardes: Exchange and Transformation, 1910–1930* (Los Angeles: Los Angeles County Museum of Art, 2002), 39–40.

61 The original meaning of *aesthetic* (the theory of sensory perception) is being used here. Susan Posman, *The Aesthetics of Matter: Modernism, the Avant-Garde and Material Exchange* (Berlin: Walter de Gruyter, 2013), 5, 7.

62 Virág Molnár, *Building the State: Architecture, Politics, and State Formation in Post-War Central Europe* (London: Routledge, 2013), 71–91.

63 Virág Molnár, "In Search of the Ideal Socialist Home in Post-Stalinist Hungary," *Journal of Design History* 23, no. 1 (2010): 65. In regard to the campaign that introduced the "contemporary style" of modern furnishings, see Fehérváry, "Goods and States," 451.

64 As cited in Molnár, "In Search of the Ideal Socialist Home," 4.

65 Molnár, *Building the State,* 90.

66 Molnár, *Building the State,* 79.

67 Christina Lodder, Maria Kokkori, and Maria Mileeva, *Utopian Reality: Reconstructing Culture in Revolutionary Russia and Beyond* (Leiden: Brill, 2014), 194.

68 György Berkovits, a well-known sociologist and novelist, wrote an intimate yet searing portrait of this expanding urban sprawl around Budapest in his groundbreaking ethnography *Világváros határában* (Budapest: Szépirodalmi Könyvkiadó, 1976). See Molnár, *Building the State,* 90.

69 Molnár, "In Search of the Ideal Socialist Home," 78.

70 As Péter Korniss stated: "I did not even attempt to be objective; after all, what I saw and experienced prevented me from taking pictures like a stranger. Furthermore, through the [thirty-one] years most of the people on these photographs became close friends, treasured acquaintances. The truth is, I could not have worked otherwise." See Péter Korniss, *Inventory: Transylvanian Pictures, 1967–1998* (Budapest: Officina Nova, Kreatív Média Műhely, 1998), 7; and Péter Korniss, *Attachment, 1967–2008* (Budapest: Helikon, 2004), 6–7.

71 Péter Korniss and Ágnes Losonczi, *A vendégmunkás: Fényképregény* (Budapest: Mezőgazdasági, 1988), 147.

72 Even though their assessment in the early 1970s was correct, no new class gained power in the mid-1980s. See Birgitt Nedelmann and Piotr Sztompka, eds., *Sociology in Europe: In Search of Identity* (Berlin: W. de Gruyter, 1993), 154.

73 As Virág Molnár argued, private building reflected the idiosyncrasies of postwar modernization and the "spatial inscription of social inequality in state socialist Hungary." See Molnár, *Building the State,* 89.

74 Gough, *A Good Comrade,* 186–87.

75 See Tökés, *Hungary's Negotiated Revolution,* 147. For this crisis of reform and its impact on the progressive avant-garde, see Cseh-Varga, this volume.

76 Heller et al., "Structural Changes," 162, 166.

77 Gough, *A Good Comrade,* 188.

78 István Rev, *Retroactive Justice: Prehistory of Post-Communism* (Stanford, CA: Stanford University Press, 2005), 5–6.

79 Péter Apor, *Fabricating Authenticity in Soviet Hungary: The Afterlife of the First Hungarian Soviet Republic in the Age of State Socialism* (London: Anthem, 2013), 207.

80 Tony Judt, *Postwar,* 412.

81 Jean-Luc Godard's 1960 film *Le petit soldat* shows photographs (pages from *Life* magazine and *Paris Match* of the 1956 Hungarian revolution) of victims displayed on a living room wall,

casually and without much feeling. Thank you to Isotta Poggi for bringing Godard's film to my attention.

82 Tony Judt, *Postwar,* 425.

83 As quoted in Kemp-Welch, *Antipolitics in Central European Art,* 7.

84 Sándor Pinczehelyi, email correspondence with the author, 9–10 July 2017: *Sickle and Hammer I* is the actual artwork that came out of the process. It is a separate photograph taken by the photographer Katalin Nádor, who also took the photographs of the artist posing with the sickle and hammer in different configurations for the series *Sickle and Hammer II and III.* Pinczehelyi used *Sickle and Hammer I* everywhere (exhibitions, publications, etc.).

85 Ernő Rubik, a young Hungarian professor of architecture, worked in the Department of Interior Design at the Academy of Applied Arts and Crafts (Iparművészeti és Iparművészeti Akadémia) in Budapest in the 1970s. He thought of the Cube primarily as an art object, a mobile sculpture. See "The History of the Rubik's Cube," Rubik's: The Home of Rubik's Cube, https://www.rubiks.com/about/the-history-of-the-rubiks-cube.

DÁVID FEHÉR

RELATIONS AND REALITY
AVANT-GARDE ARTISTS AND APPLIED ARTS BEYOND THE 3TS

In the early 1970s, the Hungarian artist Gábor Attalai created a series of photograms titled *Relations and Reality.* These works, found today in the Harald Szeemann archive at the Getty Research Institute, depict everyday objects: a flower, a lightbulb, a triangle drafting tool, and a milk package. The series clearly refers to László Moholy-Nagy and the traditions of modernism, but it is also linked to the contemporary trends of conceptual art. Attalai confronts real objects with their imaginary imprints and negative contours and thus investigates the artistic questions of representation in the spirit of Joseph Kosuth. He presents the real objects and their photograms side by side (fig. 1). Each object in the series has a small label with an inscription that describes it with irony and humor. Attalai plays with different viewpoints in the inscriptions on the work: he confronts the world "as you see it" and "as the photo-paper sees it." In a subsequent series, he takes a photo of the whole constellation and then turns the photo into a negative. On the last piece is a blank page with the inscription "as this matter [the paper] sees it."

The tautological series of photographs made of photographs reflect on epistemological questions and contemporary dilemmas of media theory in the spirit of Marshall McLuhan.[1] The title of both series, *Relations and Reality,* may also refer to the title of Harald Szeemann's 1972 Documenta exhibition, *Questioning Reality–Pictorial Worlds Today.*[2] Attalai investigates how the human gaze is manipulated by the media. On one of his works, made in the same year, he created a photogram of a shiny television screen.[3] On the surface of the photographic paper, a phantomlike silhouette appears: the subject of the work's title, *Portrait of a Hungarian Actor* (fig. 2). The negative picture of the television screen can be seen as an imaginary imprint that turns the images of mass media into a nearly undecipherable, loosely abstract vision. Attalai reveals the fictional character of media images and thus reflects on the complex relationship between fiction and reality. These dilemmas are saturated with hidden political meanings, especially when they are addressed in the context of a dictatorship, where mass media and human perception were controlled and manipulated by the state. The photogram of the barely visible face of a "Hungarian actor" was sent to Harald Szeemann, the artistic director of Documenta. This photogram may reflect the invisibility of the Hungarian art scene and the isolation of an artist who had hardly any chance to present his work to a local or an international audience. Attalai created visual imprints of everyday life, and he addressed the question, How can someone "act" in a world where "relations and reality" get confused?

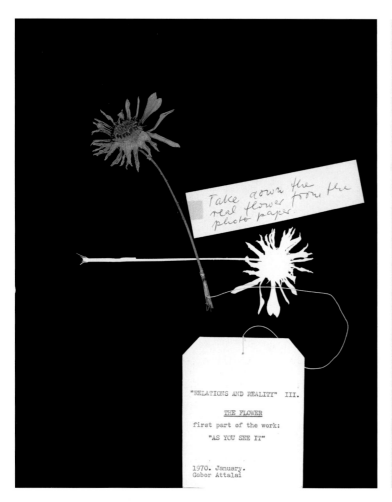

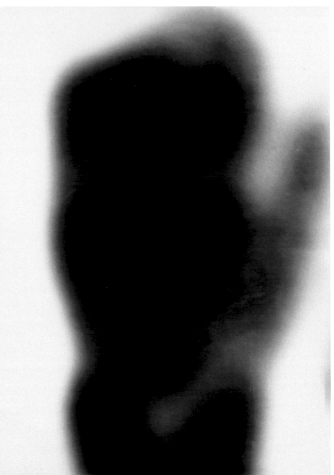

Attalai confronted antithetical viewpoints in his photoworks, and these ambiguous relations characterize his life strategy and early artistic career as well. Attalai, as did many other major figures of the Hungarian avant-garde,[4] led a "double life" in the 1960s and 1970s. On the one hand, he created subversive conceptualist works that were barely tolerated by the Kádár regime's cultural policies, the so called 3Ts—*támogatni, tűrni, tiltani* (promote, tolerate, ban). But on the other, Attalai was one of the most acknowledged and even state-supported figures of the contemporary scene of applied arts. In this essay, I aim to present some ambiguous artistic positions and personal life strategies that went beyond the categorical system of the 3Ts. I will investigate how certain barely tolerated artists of the new avant-garde—Gábor Attalai, Miklós Erdély, László Lakner, and György Kemény—defined the visual culture of Budapest in the 1960s as successful applied artists.

The catalog of the *IV. Országos iparművészeti kiállítás* (Fourth annual exhibition of applied arts), organized in 1959 at Műcsarnok, the most important exhibition hall in Budapest, gives a broad overview of the Hungarian visual culture in the years of János Kádár's consolidation after the 1956 uprising. Although the influential art historian Gábor Pogány, in his introductory essay to the catalog, praises the "emergence of Social-ist applied arts,"[5] the style of the furniture and interior design pictured in the catalog could also be described as "Cold War modern," because it reflects a similar attitude to Western trends of applied arts.[6] Gábor Attalai, who was trained as a textile designer at the College of Applied Arts Budapest (Iparművészeti Főiskola), displayed a curtain at the annual show. On the surface of the textile, stylized figures form a construction scene.

FIG. 1.
Gábor Attalai (Hungarian, 1934–2011).
Relations and Reality III: The Flower, first part of the work: "As You See It," 1970–72, photogram and flower, 30.2 × 24 cm.
Los Angeles, Getty Research Institute.

FIG. 2.
Gábor Attalai (Hungarian, 1934–2011).
Portrait of a Hungarian Actor, 1972, photogram, 30.2 × 22 cm.
Los Angeles, Getty Research Institute.

The composition evokes the topoi of Socialist realism, but the depicted setting seems to turn into its own parody. Poor stickmen are substituted for the muscular workers, and the soft surface of the curtain represents the brick wall they are building. In his early designs, Attalai seems to deconstruct Socialist realism and creates a peculiar modernistic visual language. Parallel to his activity as a textile designer, he created abstract paintings and participated in private exhibitions organized in the apartment of Pál Petri-Galla, who was a legendary figure of Budapest's underground in the 1960s.[7]

In the second half of the decade, Attalai became one of the initiators of a textile art movement in Hungary.[8] Although the latest trends in Western contemporary art were not compatible with the state's cultural policy, which promoted "Socialist" art, it was possible to present them in the most prestigious official institutions under the category of applied and decorative arts, as Attalai remembered in an essay written in 1988:

> While the so-called major arts, painting and sculpture had been willy-nilly walking in the clouds, decorative arts, as the watchmen paid less attention, began quite an earthly organization full of hopes to reshape the present according to their will. A young company of decorative artists had taken into their hands the management of their own affairs in the Association of Hungarian Artists, and set themselves to remove the barriers.[9]

The premier event of this movement was the exhibition *Textil falikép 68* (Textile mural 68).[10] The show took place in 1968, the same year as the so-called first Iparterv exhibition that introduced a new generation of Hungarian avant-garde artists.[11] The Iparterv exhibition—which was installed in the main hall of an architecture office in Budapest—featured works related to the trends of post-painterly abstraction, hard edge, shaped canvas, "combine" painting, and pop art. Typically, these artistic trends in the fine arts could not be shown in leading state-run exhibitions; it was only possible to display them in semiofficial shows. Although several works in *Textile Mural 68* were related to minimal art as well, it was possible to exhibit them in the Ernst Múzeum, an important venue of the state-supported art scene, because they were presented under the category of applied arts.

Attalai designed the cover of the exhibition catalog. A repetitive sequence of black dots recalls the aesthetics of minimal art, but it was seen as decorative and therefore compatible with modern Hungarian design of the time. In the exhibition, Attalai showcased a textile work titled *Káró*,[12] in reference to the geometric "diamond" motif of French playing cards. The work evokes the form of a *suba*, a special cape that was a traditional garment of Hungarian shepherds. In his work, Attalai referred to a motif from everyday visual culture and folk art. He investigated the relationship between national traditions and international trends in art. In an interview, Attalai explained that the form of a *suba* implies "nonfiguration and formulation with less but more affective optical motifs."[13] And he also emphasized that "we should get closer to the notion of what is called in English 'minimal.'"

Attalai's relation to minimal art is even more obvious in his felt environments, which resemble the art of Robert Morris. However, they were exhibited not as instances of a peculiar understanding of minimal art but rather in the context of the textile-art movement. The *Textile Mural 68* show was followed by a host of textile exhibitions in Hungary; among them, the most important series was the Tapestry and Spatial Textile Biennial

(Fal-és Tértextil Biennále), organized in Western Hungary at the Savaria Múzeum, Szombathely, which was less strictly controlled than the museums in the Hungarian capital. Attalai situated his minimalist environments in the Hungarian state's institutional system as instances of applied-art works. However, it was not only the categorical system of the state-controlled institutions that Attalai questioned but also the classical notion of fine arts. Attalai's environmental works expanded the notion of easel painting and sculpture in the spirit of minimal art, and as such they could have been easily mistaken as elements of interior decoration.

During these years, Attalai experimented with other art forms that outstripped the classical notion of art. He created peculiar land-art works dug out of snow, which built on motifs similar to his textile environments. Additionally, he produced conceptual photoworks, private actions performed for the camera, as well as mail art. His works reflected with irony on the provincial and "idiotic" character of Hungarian society (*Idiotic Manner*, 1973) and the claustrophobic conditions of a dictatorship (see Cseh-Varga, figs. 4,5). In Attalai's work, motifs such as a cobblestone (*Corner*, 1970), a five-point star (*Negative Star*, 1970–71), and a monochrome field of red (*Red-y Made* series, 1974–78) are elements of geometric structures and emblems of a repressive political system. However, Attalai himself was part of this system as an exhibiting artist, because he took advantage of the authorities' ignorance and inattention. Attalai's state-promoted and oppositional life and art were intertwined. This duality in his local reception clearly reflects the dysfunctional cultural political system of Hungary and how artists existed in the undefined gray zones between the imaginary categories of the 3Ts.

The emergence of experimental textile art was not exclusively a Hungarian phenomenon. Similar trends appeared in Poland,[14] and the examples presented here can be related to a broader international discourse in connection with the Lausanne International Tapestry Biennials. In the Hungarian applied art scene, several artists, including Attalai, experimented with new forms of textile art.[15] The minimalistic spatial structures composed of repetitive forms by Margit Szilvitzky and the conceptually oriented textile-objects of Zsuzsa Szenes are of similar importance. Szenes created soft everyday objects made of brightly colored wool that were intentionally dysfunctional. Her blue textile gas mask (*Functional Object Before–Decoration Now*, 1975), rainbow-colored wool sentry box (*Against Cold Weather*, 1976), and felt Gillette razorblade (*Softened Gillette*, 1975) can be interpreted as instances of a peculiar "female pop art" that evokes the effects of mass culture and everyday design with humor and irony. Nevertheless, they were presented in the context of applied arts.

Szenes was married to Miklós Erdély, a legendary figure of the Hungarian oppositional art scene whose activity is usually linked to conceptual art. His work regularly addressed the Hungarian Jews' traumatic past, anti-Semitism, recent discoveries of quantum physics, and the notion of creativity as an artistic principle. Erdély was originally trained as an architect, and he worked in several architecture offices to earn a living. In 1966, he developed a special wall decoration technique he named "photomosaic,"[16] which he described as follows:

> The essence of the innovation called photomosaic is based on the optical effects that characterize the general visual impression of the so-called rasterized photograph. The photograph should be divided into its primary elements; in which case,

every raster point represents a value of tone. If enough tones are available, we can put the whole picture together by substituting the raster points with mosaics.[17]

A lesser-known part of his oeuvre, the photomosaics had motifs and spatial contexts that varied widely. Erdély created a large advertisement for OTP Bank (National Savings Bank) on the facade of a building in a residential housing block in Budapest. It depicts an idealized young couple looking at their passbook with great optimism. Erdély's photomosaic portrait of Vladimir Lenin was made in the same period. The work served as a decoration in the building of the Eighth District Committee of the Communist Party. The smiling and waving dictator resembles a peculiar "pop icon" in the rasterized photograph.

The regular venues for Erdély's photomosiacs were bistros, restaurants, and small cafés (see, for example, *Esperanto Bistro and Café,* about 1974). The compositions were usually formed of boldly colored photographic images from the mass media ordered in a montagelike structure. In several cases, Erdély collaborated with other avant-garde artists—such as Sándor Altorjai, Tamás Hencze, and Gyula Pauer—during the preparation of a composition. He created a photomosaic for Budapest's Márka restaurant in collaboration with László Lakner (fig. 3), one of the most important Hungarian painters of the

FIG. 3.
Miklós Erdély (Hungarian, 1928–86) and László Lakner (Hungarian, b. 1936).
Photomosaic in Márka restaurant, Budapest, late 1960s or early 1970s.

period. The central motif of the composition is a photograph of a woman standing, and the figure of another woman repeated four times in the background, evoking the repetitive structures of Warholian pop art and Eadweard Muybridge's chronophotography, both of which are important references for Lakner's works from the 1960s.

Indeed, Erdély's photomosaics evoke the aesthetics of international pop art. As Géza Perneczky, the influential art critic of the 1960s, remarked in 2004:

> [Erdély] remained very true to the raw photographic prototypes, to the commercial themes, and to the world of consumer goods to such an extent that he could very authentically represent the consumer world presented in pop art. These works remained closer to the international line of pop art than the other provincially stylized and aestheticized pop experiments in Hungary.[18]

Erdély, in contrast to Attalai, mainly considered his activity in the field of applied arts as a source of income, rather than an integral part of his oeuvre. Nevertheless, the photomosaics are a very important contribution to the histories of art and design in Hungary. They are defining elements in the period's visual culture. The resemblance of the photomosaics to pop art is not a coincidence. In 1968, Erdély wrote a manifestolike text titled *Pop tanulmány* (2015; On pop art),[19] in which he reflected on the questions of mass culture and fashion in relation to the contemporary trends of pop art. Two years earlier, he published the essay "Montázséhség" (1966; A hunger for montage), in which he discusses the importance of montage in relation to not only film but also music and the visual arts, mentioning Robert Rauschenberg's compositions in the context of Dadaism, surrealism, futurism, and abstraction:

> And recently the scorned and triumphant pop art makes desperate and occasionally reckless efforts to rescue the static object montage, making use of the lame expressiveness of assembled objects. As if, instead of film, it were being active, with an inventiveness that films greatly lack. It does not hesitate to mount photographs and newspaper photos next to each other either, to the extent that some of Rauschenberg's pictures appear as if they were the memories of a news report.[20]

Erdély's photomosaics recall Rauschenberg's montage technique and the imagery of pop art, which were compatible with the principles of modern Hungarian interior design in the late 1960s.

The rethinking of Western pop imagery in the Eastern bloc was a recurring question in the fields of fine arts and applied arts in the second half of the 1960s. One of the central figures in this discourse was László Lakner. He started his career in the early 1960s as a figurative painter associated with a local variant of surrealism. Then, he created works related to American and British pop art that were also linked to the local discourses on realism. The political status of Lakner's figurative painting was ambivalent in the early 1960s: it was compatible with the regime's viewpoint because of its realistic character, but it was problematic due to its Western orientation. Lakner's art was in an undefined gray zone of the fluid categorical system of Kádár's cultural politics. His works were regularly displayed in the annual exhibitions of the Studio of Young Artists (Fiatal Képzőművészek Stúdiója), the most important state-run institution for emerging painters

and sculptors, but there were occasions when his works were denied by the official jury because of obvious political reasons.[21]

Similar to Erdély, Lakner earned his living through work in the applied arts. He was active as an illustrator for weekly newspapers and book editions, and he won some competitions for wall decoration, although in most cases this privilege was reserved for state-supported artists. In 1962, he created a large secco for the Savoy restaurant in downtown Budapest.[22] The wall painting depicts a modern cityscape composed of perspective lines. The work oscillates between figuration and abstraction and has a utopian character that suited the progressive ideas in wall decoration in the early 1960s. During these years, Lakner occasionally was commissioned to create architectural decorations. In most cases, these commissions were related to his childhood friendship with the influential contemporary architect Imre Makovecz. In 1965, Lakner designed a relief for a honey factory designed by Makovecz.[23] The monumental depiction of a beehive relates to Makovecz's organic architecture style, yet, the manner of enlargement and the inventive use of direct imprints, which recall Eduardo Paolozzi's sculptures, correlate with Lakner's early experiments with the visual effects of pop art.

Lakner's most monumental but ultimately suspended architectural project was his 1969 *Rose* sculpture, which was based on an enlarged rose in the spirit of Claes Oldenburg (fig. 4). The three-meter-high bronze sculpture was meant to be a fountain in the garden of the prestigious Halász Bástya restaurant in Budapest's Castle District. The sculpture would have been a unique example of a state-supported public art commission clearly related to American pop art, but the finished sculpture was never installed at the planned venue. The authorities made this decision after Lakner moved from Hungary to West Germany in 1974 and was, consequently, labeled a dissident.[24] The *Rose* was finally erected in 1989 in a housing block in a Budapest suburb. It stands as a puzzling memento to the ambiguous reception of progressive Hungarian art in the 1960s and 1970s.

In his Hungarian period, Lakner's most important source of income was his work as a graphic designer. Although he thought of these pieces as works for hire, his movie

FIG. 4.
László Lakner (Hungarian, b. 1936).
Plaster mold for *Rose* sculpture, 1969,
height: ca. 3 m.
Photo by György Gadányi.

and theater posters can be interpreted as extensions of his painterly practice. In his posters and paintings, Lakner used similar visual effects that referenced pop art. Though in the field of painting and the fine arts in general, Lakner's compositions were treated as ideologically problematic because of their Western orientation, they were not only popular but defined the visual culture of the times in the field of applied arts.

Lakner's early career was shaped by the "first pop age," when the boundaries between mass culture and high art dissolved.[25] Lakner often employed motifs that are typical for graphic design in his paintings. Other important references for Lakner's painterly and design practices were Robert Rauschenberg's montagelike compositions based on images from the mass media, which Lakner saw at the 1964 Venice Biennale, and the posters of the leftist artists John Heartfield and Ben Shahn.[26] The combination of text and image define Lakner's paintings of the time. Such combinations also occurred in his movie posters, which drew on the aesthetics of international pop art (see the movie posters for *Jowita* [1967] and *The Man I Love* [1966]). However, in several cases, the posters were created for films with leftist content. For example, Lakner designed the poster for Imre Gyöngyössy's movie *Virágvasárnap* (1969; Palm Sunday) (see Cuevas-Wolf, fig. 8), which thematizes the history of the Hungarian Republic of Councils, a recurring subject in Lakner's conceptualist works and photorealist paintings from the early 1970s (see *Me, One of Them* [1970] and *Revolutionary Group* [1970]).[27]

After ending his "pop period" in the late 1960s, Lakner created photo-based conceptualist works and photorealist paintings. In his photorealist paintings, he addressed questions of historical traumas and social issues through reproduced documents, such as magazine illustrations, postcards, filmstrips, and telegrams. It was nearly impossible to present Lakner's paintings and conceptualist pieces in the Hungarian institutional system of the early 1970s, but his posters from the same period were permanently displayed in the streets and in the field of Hungarian visual culture. Ironically, the artist used the same visual elements and motifs in his barely tolerated paintings and photoworks. The inventive use of filmstrips as artificial frames within the picture frames and the depiction of telegrams (seen in Lakner's paintings) recur in his posters. Hand-painted elements occasionally appear alongside the photomontages in the compositions. The hand-painted or overpainted motifs recall Lakner's earlier paintings. Based on an authentic daguerreotype, the green-colored head of the romantic poet and revolutionary Sándor Petőfi on the movie poster for *Petőfi '73* (1973) can be associated with the early paintings Lakner produced during the 1956 uprising, which depict Petőfi's head in a surrealistic way (fig. 5). The reference to the suppressed trauma of the defeated uprising, which had been one of the biggest taboos of the Kádár regime's memory politics, is present in the poster as a hidden association.[28]

Lakner's preliminary poster designs reveal an interesting transition between his practices in the fields of fine arts and applied arts. The pieces are hand-made collages combined with hand-painted elements. In one of these collages, a blue head of a Japanese woman appears, and, on top of her head, the depiction of Mount Fuji is collaged as a surrealist hat.[29] A rose motif along the border recalls Lakner's pop paintings. The enigmatic text fragments on the collage ("Big Brother" and "Von Einmarsch in Prague bis zum") evoke political connotations. Indeed, the collage made in 1970 can be associated with Lakner's photorealistic paintings, which depict motifs from the Far East, especially his monumental painting *Chinese Postcard* (1972). The painting depicts a postcard with a

For over a decade, the art historian Edit Sasvári has argued that art and politics interacted under real existing Socialism[11] from the mid-1960s to 1975 — one of the most exciting periods of Kádárist Hungary, because the rules determining which art was blacklisted and which was supported were no longer carved in stone.[12] During this period, Kádár consolidated his soft dictatorial power and introduced economic and cultural reforms. The resulting optimistic atmosphere completely changed with the crushing of the Prague Spring in 1968. A domestic political crisis erupted in Hungary with protests against the suppression of the Prague Spring, illegal student demonstrations, the appearance of independent cultural groups and music bands, and the activities of the so-called reform sociologists,[13] among other political actions.[14] Concurrently, a parallel cultural and public sphere emerged that enabled avant-garde artists to create a new phenomenological language.[15] The unfamiliar and inaccessible language of this nonconformist art led to a hostile attitude toward conceptual art and happenings by the ruling Hungarian Socialist Workers' Party (Magyar Szocialista Munkáspárt, or MSZMP).[16] This hostility found expression in strategic and cryptic games by artists jockeying for favor with the state and a regime determined to exercise authoritarian control over avant-garde art. Antagonism, often motivated by personal interest rather than politics or ideology, formed the backdrop against which progressive artists had to live and work.

Kádár's paranoid regime produced an immense number of textual documents as part of its bureaucratic control over Communist life and its ad hoc gathering of surveillance data. In 1957, Kádár stabilized his power by defining a Socialist ideology that, in the words of Emese Kürti, was "alternating between restrictiveness and tolerance."[17]

The ideological, mechanical language used in secret-police reports stands in sharp contrast with the photographic experiments and radical aesthetics of the avant-garde. In the arts, photography was turned into a self-reflexive, critical medium that by the early 1960s escaped rationalization or institutionalization. As of the 1970s, directness and physicality were characteristic of not only a radical Western photo scene but also conceptual art being made behind the Iron Curtain. Photography as conceptual art was considered "equivalent to other artistic media" and used as a creative tool in East-Central Europe's nonconformist art.[18] Photography became part of the artistic process, and, as a form of communication, it was analyzed for its potential in expanding the possibilities of conventional art production.[19] Although the photographic snapshots taken at the Chapel Studio in Balatonboglár and the photoworks by Attalai transmit the physicality of the events, it is because of their coded language that interpretation was restricted to a limited few and perceived as elusive by a bureaucratized world controlled by propaganda and ideological doctrine. In this way, the Hungarian avant-garde's photographic documents keenly undermined the Workers' Party's cultural politics in a clandestine way.

In order to understand the avant-garde's photographic strategies that effectively challenged the bureaucratic practices of the Kádár era, it is necessary to look closely at the often paradoxical official attitude toward nonconformist art. Ideological demonization stands out in the narrative reports. For example, in a report on the radical artist Tamás Szentjóby and his happenings and Fluxus activities, secret agents, who possessed some analytical ability, screened one of his avant-garde happenings and contrasted the attributive language of this complex art form with values of Socialism, as summarized in the opening lines of a report: "A happening, as regards its philosophical aspect, is a declaration of nihilism, darkness, irrationalism, and the denial of healthy human activity.

Its religion is aggression and hysteria. Its practical realization serves the purpose of scandalizing the public and asserting exaggerated decadence."[20]

There were very few agents who understood the artists' intentions and could read the visual codes with an analytical eye. A case in point is a detailed report by the agent "Mészáros" describing Szentjóby's and Gábor Altorjay's 1966 happening. It inaccurately incorporated historical sources to delineate the origins of the phenomenon.[21] Most of the secret police's surveillance documents are written in an objective language as follows: "We have established that György Galántai continues to pursue rebellious activities directed against the party's general and cultural policies. . . . His propaganda materials and calls to action encourage participants to produce 'works of art' with politically objectionable hostile content."[22] However, the style of László Algol´s reports differ from these surveillance documents significantly. Algol was a writer, an artist, and a member of the avant-garde art scene. He not only cooperated with the experimental theater group Kassák House Studio (Kassák Ház Stúdió) but also exhibited and performed at the Chapel Studio in Balatonboglár. As a double agent, Algol represented the paradox of Kádár's cultural politics: besides being a practicing artist of the avant-garde, he reported regularly to the secret police.[23] The obligatory and expected use of certain expressions was common practice in the narrative reports of the secret police, and although they can still be recognized in Algol's language, his association with as well as integration into the underground art world is readable in his texts. On the one hand, Algol's excellent descriptions of and investigations into Galántai's samizdat activity reveal Algol to be a controversial figure — a creative and talented analyst/theoretician who was no less harmful to the artist as his agent-colleague.[24] On the other hand, in his writings on the avant-garde Kassák House Studio, which formed around Péter Halász, Algol's reports seem to be "supportive," in that he disclaimed any political message inscribed into the performance pieces because, according to Algol's official review, they were only done to gain attention.[25] Although there weren't any direct political or aggressive countercultural topics in Galántai's samizdat publications, Szentjóby's and Altorjay's happening, or the Kassák House Studio's performance productions, these artists rebuffed the artistic norms and communication policies commanded from "above," because they were constantly aware of the artificial ideological warfare created by Kádárist cultural politics. Despite the fact that the position of reporting agents was not always clear or self-explanatory, and the files contained disputed statements, it was the official, alienated language of the regime that the avant-garde's autonomous, provocative, and offensive practices negated.[26] The photographic works discussed below demonstrate how aesthetic nonconformism opposed the ideological (textual) language dictated by Socialist policy in Hungary.

During the three summers of its existence, from 1970 to 1973, an incredible photographic archive was produced from the program of György Galántai's Chapel Studio in Balatonboglár. Although the studio was operating legally, it was an artistic pool, an assembly of avant-garde artists, located more or less on the margins of state-promoted aesthetics.[27] No matter what happened in and around the Chapel Studio, Galántai was conscious about taking care that each event was photographed and thereby documented. The carefully stored materials served as the foundation for the Artpool Art Research Center, founded in 1979. Artpool's philosophy of making available an open collection, and promoting the circulation of information, makes it clear how the institution aimed to produce an alternative archive based on avant-garde art and new forms of social

activism.[28] The core ideas of this form of knowledge and art production were already existing at the beginning of the seventies in Balatonboglár. Artists who accepted the unwritten rules resisting the regime's system of art directing (művészetirányítás) could be part of the project. Artpool's/Galántai's documentation of photo-body art actions captures the phenomenon of stop-motion, a clearly marked interruption of the performance that either celebrated the experiment or highlighted subversion.

The first action and happening organized at the Chapel Studio took place on 2 July 1971. In *Direction-Showing Action* (*Irányjelző akció*), Gyula Gulyás investigated in a minimalistic way the relation of geometric abstraction and the human body, two elements alien from each other.[29] The action is documented in three photographs: the first image shows Gulyás adjusting his lying, static body to a white L-shaped stripe painted on the pavement in front of the chapel's entrance (fig. 2); the second one illustrates the artist standing on the stripe looking up; and, in the third image, we see Gulyás with four additional men standing on the outer edge of the white stripe, all of them looking directly into the camera. In all three photographs, it is striking how the subjects are focusing on the moment of stop-motion. *Direction-Showing Action* exhibits an organic photographic characteristic that Susan Sontag called "slicing out [a] moment and freezing it."[30] Gulyás's piece is much closer to body art than to process-based art, because it is focusing on the gesture of posing. The pose, the geometric two-dimensional object, and the entry of the camera into the reality of the two compose a photographic image. Pausing, transforming the frozen moment into the picture,[31] and showing the temporary break explicitly are essential to the experimental spontaneity realized at Galántai's art venue. The objectification happening in *Direction-Showing Action* stands in contrast to the control exerted by the Communist regime over people's bodies: the privacy, communication, behavior, and actions of every individual were influenced by the state's efforts to implement Socialism.[32]

FIG. 2.
Gyula Gulyás (Hungarian, 1944–2008).
Direction-Showing Action (*Irányjelző akció*), 1971,
Chapel Studio, Balatonboglár, 35 mm slide.
Budapest, Artpool Art Research Center.
Photo by György Galántai.

In another example, stop-motion, as a minimalistic intervention captured in the photograph, is related to the notion of deception frequently used in Gyula Pauer's artistic strategies. An everyday action transformed into an art piece is what characterizes Pauer's *Flyer Action (Röpcédula-akció)*. The artist subverted the practice of distributing propagandistic flyers in a way that mocked the visitors to the Balatonboglár studio. Pauer disseminated a number of flyers (including a miniature self-portrait of himself with the inscription "PAUER: PSZEUDO 1971, BOGLÁR") around the chapel and glued them to the ground (fig. 3). Passers-by were desperate to pick them up from the ground, but in the very moment they tried to do so, they realized they had been fooled.[33] Critically juxtaposing the propaganda communication apparatus of the Kádár era with countercultural samizdat, Pauer reached his goal of anonymously persuading individuals to perform action. Information provided by the artist was extremely limited, so passers-by needed to find a way to engage with a single piece of paper lying on the ground.[34] When photographing a chosen moment, there is a certain amount of freedom and nonrepressive control over a situation.[35] The fascination with photography in the

FIG. 3.
Gyula Pauer (Hungarian, 1941–2012).
Flyer Action (Röpcédula-akció), 1971, Chapel Studio, Balatonboglár, 35 mm slide.
Budapest, Artpool Art Research Center.
Photo by György Galántai.

context of Balatonboglár can be derived from the avant-garde's aim to develop a field in which it could act autonomously. They broke with the Socialist norms of perception and presentation, while their underground photography "generate[d] its own idea of a phenomenon."[36]

Although stop-motion is almost always inscribed into a photograph, it might be hard to imagine how flow—the creative process—could be incorporated into a two-dimensional static object. The physical movements Gábor Attalai captured in his photoworks, particularly the performative moments, use flow to oppose the stasis and strict structures of propaganda, which denied experimental aesthetic expression and insisted on certain "fixed" images and texts. Flow was the phenomenological counterlanguage of Socialist culture and its political order.

In recent theories of photography, it has been asserted that the medium cannot be simply reduced to its outcome (the photograph). Richard Shusterman suggested that one has to go beyond the single image and look at photography as "a process of setting up, preparing, and taking the photograph shots in a photography session."[37] This process is especially true in the case of the "performed photography" Attalai staged in front of and around the camera. In positioning his body in front of the camera, Attalai was not simply documenting a performance, he was creating the artwork—namely, the photograph that contains the performative act, which makes us think beyond what we see in these images. In his photoworks, Attalai broached the issue of intense physical interaction with his own body, including the testing of the power of endurance of his sensual organs. Vulnerability, as well as elusiveness of the body as a material and live object, were captured in his photo actions. The body as live object represents the flow in Attalai's works. As stated by the artist in an interview, all of his experiments with conceptual art and photography were forms of escape.[38] Yet, he clearly distanced himself from forms of (regime) provocation practiced by artists such as Tamás Szentjóby.

To illustrate the idea of process as flow, I am highlighting three photo-body art actions by Attalai: *Idiotic Manner I-II-III* (1973; also called *I Can Be Foolish Too I-II-III* [*Én is hülyítettem magam I-II-III*]), *No Air* (1971), and *Cutting a Wart Off My Breast I-II-III* (1971). *I Can Be Foolish Too* is a series of three photographs that show close-ups of Attalai while he tries to stick his big toe into his nose (fig. 4), sucks his big toe (fig. 5), and pushes

FIG. 4.
Gábor Attalai (Hungarian, 1934–2011).
Idiotic Manner I (Én is hülyítettem magam I), 1973, gelatin silver print, 14.5 × 19.5 cm.
Budapest, Gábor Attalai Estate at Vintage Galéria.

FIG. 5.
Gábor Attalai (Hungarian, 1934–2011).
Idiotic Manner II (Én is hülyítettem magam II), 1973, gelatin silver print, 14.5 × 19.5 cm.
Budapest, Gábor Attalai Estate at Vintage Galéria.

FIG. 6.
Gábor Attalai (Hungarian, 1934–2011).
No Air, 1971, four gelatin silver prints,
each 7.5 × 18 cm.
Budapest, Gábor Attalai Estate at Vintage Galéria.

his index finger into his nose. The individual photographs may seem to document single poses, however, like a series of shots in a film, they are a montaged sequence of actions. The piece is unique in Hungarian avant-garde photography because it is playful, not serious, and suggests a sense of freedom. *I Can Be Foolish Too* was seen as a commentary on the Communist system's "functioning madness," because, according to Attalai, "anyone who did not want to go crazy in communist countries had to act like he was crazy."[39] Both *No Air* and *Cutting a Wart Off My Breast,* among others, represent Attalai's relationship to the political and cultural context he was acting in. *No Air* (fig. 6) is a collection of five photographs showing the head of the artist from below his nose to the upper section of his chest. The five snapshots depict Attalai removing an adhesive tape from his mouth and then plunging it into his right nostril. On the one hand, this is a playful, childish illustration of losing one's mind in the oppressive atmosphere of the Kádár regime. On the other hand, it refers to the breathless/wordless sphere of everyday existence. In *Cutting a Wart Off My Breast* (fig. 7), one can only witness the consequence of Attalai's action. A series of three images reveal a close-up of Attalai's naked chest. The viewer is directed to look at the partly shaved area of his thorax, where a narrow stream of blood trickles down. This works alludes to the suffering caused by the regime's manifold restrictions; it is also a demonstration of an experimental freedom, outside the sight of the party, that only a minority enjoyed. Both performative photoworks summarize a process while guiding our gaze to acts of subversion against censorship—Attalai punished himself before the system could punish him. As Dávid Fehér pointed out, materiality is essential to these photo actions because of their transportability as photographs.[40] Yet, these photos visualize a flow (before and after the snapshots were taken) that associates Attalai's work with immateriality. Because his work is ensconced in the Kádár era's cultural climate, Attalai's nonpublic performances and actions represent an antipolitical art that reflects on the "artistic and existential symptoms of constrained living within the system."[41]

But what do Attalai's works suggest in terms of documentation? Beginning in the early 1970s, communication through photography became increasingly widespread

FIG. 7.
Gábor Attalai (Hungarian, 1934–2011).
Cutting a Wart Off My Breast II, 1971,
gelatin silver print, 18 × 24 cm.
Budapest, Gábor Attalai Estate at Vintage Galéria.

in avant-garde aesthetics in Hungary. Photography was used as a documentary tool to produce individual microhistories, but underground artists took it farther. Attalai's alliance with the camera made the medium the coproducer of his photoworks.[42] All three pieces discussed above are evidence of where the artist indirectly positioned his corporeal presence in the paradoxical reality of Kádárist Hungary and how the camera silently communicated his relation to the process (or flow) of art production. From a historical point of view, Attalai's conceptually inspired photo-body art actions function as documents left to comment on the conditions under which they were produced.

Both the Chapel Studio and the Attalai examples discussed here demonstrate the tenuous relation between the vacuumlike atmosphere of Cold War Hungary and the few venues for pseudo-autonomous art production. The tension and overlap between these spheres resulted in direct and indirect communication through new, diverse art forms. In late-Socialist cultural politics, complex decision-making processes and uncertainties about creative innovations led to varying degrees of tolerance and then outright prohibition.

The integration of document and event is most visible in the work and legacy of György Galántai: through his experiences at the Chapel Studio in Balatonboglár, he created his extensive archive, Artpool. From a very early age, Galántai was a passionate diary writer, although at the beginning he only communicated with himself. In establishing the Chapel Studio, he extended this communication to a larger group of avant-garde artists. For Galántai, experimental, subversive documentation went hand in hand with creating performative histories, which allowed him to transform his understanding of a Gesamtkunstwerk into an active, live archive that still has a strong research interest in the performative arts.

The photo actions at the Chapel Studio and those executed by Attalai are not simply referencing exclusions, repressions, or interruptions in the timeline of art history; rather, they are complex manifestations of how performance artists rebelled against, ignored, and subverted the manipulations and obstacles of the Kádár regime.[43] X

NOTES

1 Oliver Wendell Holmes, cited in Leigh Raiford, "Photography and the Practices of Critical Black Memory," *History and Theory* 48, no. 4 (2009): 113.

2 Donna West Brett, *Photography and Place: Seeing and Not Seeing Germany after 1945* (New York: Routledge, 2016), 101.

3 Allan Sekula, cited in Leonia Kovač, "Photography in the Context of Biopolitics," *Život Umjetnosti* 89 (2011): 38, 43; Sekula, "The Body and the Archive," *October* 39 (1986): 3–64.

4 Sven Spieker, *The Big Archive: Art from Bureaucracy* (Cambridge, MA: MIT Press, 2008), 11–12.

5 West Brett, *Photography and Place,* 100–102.

6 John Szarkowski, "New Photography 2: Mary Frey, David T. Hanson, Philip Lorca diCorcia," *MoMA,* no. 41 (1986): 2.

7 Sándor Szilágyi, *Neoavantgárd tendenciák a magyar fotóművészetben 1965–1984* (Budapest: Új Mandátum, 2007), 335.

8 Hal Foster, "An Archival Impulse," *October* 110 (2004): 4, 7, 21–22.

9 Zdenka Badovinac, *Prekinjene zgodovine = Interrupted Histories* (Ljubljana: Moderna galerija, 2006).

10 I consider neo-avant-garde art to be a counter-discourse to the late Socialist aesthetic and cultural doctrines of East, Central, and Southeast Europe. This kind of art was, in its contradictory diversity, representing a formal and content-based rebellion against modernism. Although it occasionally related to the historical avant-garde, neo-avant-garde art directly or indirectly criticized the socio-cultural circumstances of the 1960s and 1970s; and, further, it often had an experimental or structural relationship toward the concept of utopia.

11 "Real existing Socialism" reflects the contradictions between the Communist ideology and how it was actually implemented in East-Central Europe after World War II.

12 According to Sasvári, it was around this time that phenomena such as conceptual art, happenings, and other event-based art forms emerged, challenging the control system in cultural politics. Tamás Szőnyei, "Amire allergiás volt a belügy," *Magyar Narancs,* no. 10 (2003). See http://magyarnarancs.hu/film2/amire_allergias_volt_a_belugy_sasvari_edit_muveszettortenesz-55693.

13 The reform sociologists were a group of academics around sociologist István Kemény dealing with the "forbidden" issues of poverty and the situation of Roma in Socialist Hungary. They became victims of the 1972–74 party campaign against reform thinking. See also Cuevas-Wolf, this volume.

14 Edit Sasvári, "Miért éppen Pór? A kádári 'üzenési' mechanizmus természetéhez," *Országos Széchényi Könyvtár: 1956-os Intézet és Oral History Archívum. Évkönyv VIII.* (Budapest: 1956-os Intézet, 2000): 124–29; http://www.rev.hu/portal/page/portal/rev/kiadvanyok/szovegek_evk2000/sasvari.

15 Sasvári, "Miért éppen Pór?," http://www.rev.hu/portal/page/portal/rev/kiadvanyok/szovegek_evk2000/sasvari.

16 Sasvári, "Miért éppen Pór?," http://www.rev.hu/portal/page/portal/rev/kiadvanyok/szovegek_evk2000/sasvari.

17 Emese Kürti, "Experimentalizmus, avantgárd és közösségi hálózatok a hatvanas évekbe: Dr. Végh László és köre" (PhD diss., ELTE-BTK, Film, Média és Kultúraelmélet Doktori Iskola, Budapest, 2015), 58. Translation mine.

18 Sandra Križić Roban, "Experiments, Research, and Shifting the Borders of Photography Art since the 1960s," *Život Umjetnosti* 89 (2011): 14.

19 Križić Roban, "Experiments, Research, and Shifting the Borders of Photography Art since the 1960s," 15–16, 19.

20 Kata Krasznahorkai, "Surveilling the Public Sphere: The First Hungarian Happening in Secret Agents' Reports," in "Performance Art in the Second Public Sphere: Reflections on Event-Based Art in East, Central, and Southeast Europe in Late Socialism," ed. Katalin Cseh-Varga and Adam Czirak (unpublished manuscript, 2015), 1. See "Anonym Secret Police Officers: Summary Report and Action Plan Regarding Happenings (1968)," *Parallel Chronologies: An Archive of East European Exhibitions,* http://tranzit.org/exhibitionarchive/texts/agent-report-summary-report-and-action-plan/.

21 Krasznahorkai, "Surveilling the Public Sphere," 3–4.

22 Excerpts from "Összefoglaló jelentés 'Festő' fn. bizalmas nyomozásban" [BM III/III-4-b

alosztály, TH O-19618/2] (December 1982): 91–98, cited in György Galántai and Júlia Klaniczay, eds., *Artpool: The Experimental Art Archive of East-Central-Europe* (Budapest: Artpool, 2013), 107.

23 Szőnyei, "Amire allergiás volt a belügy."

24 "'Pécsi Zoltán' fn. tmb. jelentése a Galántai György által forgalmazott 'AL' c. művészeti kiadványról" [BM III/III-4-b alosztály, TH O-19618/2] (September 1983), 148–55, cited in Galántai and Klaniczay, *Artpool,* 113.

25 Kata Krasznahorkai, "Erhöhte Alarmbereitschaft: Die Kunst des Underground im Visier der Staatssicherheit: Geheimdienstakten als kunsthistorische Quellen zur Erforschung künstlerischer Aktivitäten im Underground der 1960er und 70er Jahre," paper presented at the conference "Kunst im kommunistischen Europa 1945–1989," Berlin, 19–21 November 2009.

26 Olga Martin, "Moscow Conceptualism in the 1980s: Interview with Sabine Hänsgen (Zurich)," ArtMargins Online, 25 August 2015, http://www.artmargins.com/index.php/interviews -sp-837925570/766-2015-08-28-00-33-52.

27 Szőnyei, "Amire allergiás volt a belügy."

28 "Az Artpool," Artpool, http://www.artpool.hu/Artpool.html.

29 Katalin Cseh-Varga, "Rebellische (Spiel-)Räume und Underground-Netzwerke: Die zweite Öffentlichkeit der ungarischen Avantgarde" (PhD diss., Ludwig-Maximilians-Universität München, 2016).

30 Susan Sontag, cited in Richard Shusterman, "Photography as Performative Process," *Journal of Aesthetics and Art Criticism* 70, no. 1 (2012): 67–78, 73.

31 Roland Barthes, *Die helle Kammer: Bemerkungen zur Photographie,* trans. Dietrich Leube (Frankfurt: Suhrkamp, 2009), 88; and Barthes cited in Shusterman, "Photography as Performative Process," 70.

32 Stefan Wolle, *Die heile Welt der Diktatur: Alltag und Herrschaft in der DDR 1971–1989* (Bonn: Bundeszentrale, 1999), 135.

33 Gyula Pauer, cited in "Balatonboglári Kápolnaműterem," Artpool, http://www.artpool.hu /boglar/1971/710702_p.html.

34 Cseh-Varga, "Rebellische (Spiel-)Räume und Underground-Netzwerke," 256–58.

35 Vilém Flusser, "The Gesture of Photographing," *Journal of Visual Culture* 10, no. 3 (2011): 287, 291.

36 Flusser, "The Gesture of Photographing," 283.

37 Shusterman, "Photography as Performative Process," 68.

38 Gábor Attalai, cited in Dávid Fehér, "Nem hiszek a túl direct dolgokban…Beszélgetés Attalai Gáborral," *Ars Hungarica* 37, no. 3 (2011): 120.

39 "Attalai Gábor," *Virtual Museum of Avant-Garde,* http://www.avantgarde-museum.com/en /museum/collection/4402-ATTALAI-GABOR/. See also Fehér, this volume.

40 Dávid Fehér, "Transzfer ideák: Megjegyzések Attalai Gábor konceptuális művészetéhez," in *Attalai Gábor: Konceptuális művek/Conceptual Works 1969–85,* exh. cat. (Budapest: Vintage Galéria, 2013), 4; and Attalai, cited in Fehér, "Nem hiszek a túl direct dolgokban," 116–17.

41 Emese Kürti, "A csend és az idő: Attalai Gábor (1934–2011)," *Magyar Narancs,* no. 35 (2011): 30.

42 Philip Auslander, "The Performativity of Performance Documentation," *PAJ: A Journal of Performance and Art* 28, no. 3 (2006): 5.

43 While locally conducted oral histories are one way to find out more about the remaining records documenting event-based art in Hungary, international archives, such as the Jean Brown and the Harald Szeemann archives at the Getty Research Institute (GRI), help us decipher the artistic milieu and paradoxes of late Socialism. The Jean Brown archive holds materials on György Galántai´s mail art activity, and the Szeemann collection is a valuable source to retrace the international approaches of the neo-avant-garde networkers, including artists such as László Beke, László Lakner, and Gábor Attalai. The same is true for the Michael and Carol Simon collection at the GRI, which includes materials on the Liget Galéria and the photographers György Stalter and Antal Jokesz. In a sense, the Liget Galéria furthered the semi-independency of the Chapel Studio in the 1980s; it is where the photographers Stalter and Jokesz used their cameras for conceptual creation. By studying these multiple sources on the performative arts, we gain a fuller understanding of how and why cultural politics and nonconformist artists were acting in a paradoxical relationship in Cold War Hungary.

IN THE UNDERGROUND BETWEEN EAST AND WEST

During my entire time in Hungary and later Germany, I was, in addition to my other work, active as an artist in the fields of painting and photography as well as in various new and experimental genres. In order to protect my freedom, however, I kept these activities strictly separate from my work in public institutions. In Hungary, it seemed advisable to behave in such a way because of the prevailing political repression in Communist countries, under which any artists who attempted to express themselves freely or to follow the modern artistic trends were punished. In Germany, my reasons were quite different. Having arrived in the country as an immigrant at the end of 1970, I was late in being able to establish the usual kind of connections with the visual arts scene, and I would have had practically no opportunity to be represented by the sort of galleries that corresponded to my taste and convictions. As a result, I became increasingly active in the artistic underground, a path that would lead me to the international community of artists working in the field of mail art.

My Career as an Art Critic in Hungary

During my years in Hungary, I enjoyed the favor of the editors in chief of the daily newspapers and literary journals, who repeatedly defended me — they regarded me as a kind of wunderkind — when I was threatened with reprisals from the country's cultural bosses on account of my excessively audacious publications as an art critic. I also worked as an author and presenter in the artistic programming unit of Hungarian Television. In the second half of the 1960s, I succeeded in publishing a number of books in Hungary dealing with predominantly Western contemporary art movements — for example, *Tanulmányút a Pávakertbe* (Study trip to the Peacock Palace) in 1968 and an illustrated monograph on Paul Klee (also 1968), which was the only book about the artist to be published behind the Iron Curtain during the entire fifty-year history of the Eastern bloc.

It is no surprise that a career of this kind could not simply carry on without any problems. By the time of the Prague Spring and the Soviet occupation of Czechoslovakia at the latest, a lot of things had changed in Hungary, as elsewhere, and this was particularly noticeable in the area of cultural policy. In the end, a service passport was pressed into my hand, made out for Western Europe, and my editor in chief informed me in a friendly manner that "we would not be remotely displeased, Comrade Perneczky, if you failed to return from this trip. And nothing will happen to your family either." When I indeed failed to return, the Hungarian cultural authorities — and for me too this was a surprise — were as good as their word.

I lived in Hungary until the age of thirty-four. After having worked for these various state organizations for a decade, I was given permission to take a study trip to Western Europe in 1970; in West Germany, I applied for political asylum. Ten years later, I was granted German citizenship, which meant I could visit Hungary and various other Eastern bloc countries as a tourist. I still live in Germany to this day, in Cologne, where for several decades I taught in a high school and also worked for the foreign-language broadcasters Deutschlandfunk and Deutsche Welle.

Budapest: The *Five Books*

In spite of growing personal and political difficulties, my last year in Hungary remained productive. In addition to the exhibition reviews that I was writing for a literary journal, I was already becoming more and more active in the underground.

I also published illegal material, including the *Five Books* (1970), a series of hand-made, staple-bound booklets that I distributed among my friends and acquaintances at exhibition openings. These brightly colored pamphlets contained conceptual works that were not without irony and the occasional underlying political connotation. They were realized in the style of the artists' books that were to become popular later on;

FIG. 1.
Géza Perneczky (German, b. Hungary, 1936).
Travel by T-Carriage (Utazzon T-kocsival).
From Géza Perneczky, *Five Books*, no. 5 (1970), n.p.
Los Angeles, Getty Research Institute.

FIG. 2.
Géza Perneczky (German, b. Hungary, 1936).
Look at the Beautiful Hungarian Parlament.
From Géza Perneczky, *Five Books*, no. 2 (1970), n.p.
Los Angeles, Getty Research Institute.

TRAVEL BY
T-CARRIAGE
UTAZZON
T-KOCSIVAL

Perneczky Géza 1970 JUN 23

LOOK AT THE
BEAUTIFUL

HUNGARIAN
PARLAMENT

Perneczky Géza 75/1/50

in other words, they were emphatically mixed media and comprised original works and materials. For example, the paradoxical image *Travel by T-Carriage*—in which one train wagon connects perpendicularly to another, preventing the movement of both carriages in any direction—evokes the paralysis caused by the faulty and illogical design of the political system (fig. 1). The sheet titled *Look at the Beautiful Hungarian Parlament* [*sic*] was equipped with a punched peephole through which, instead of a photograph of the well-known and much-admired Parliament building in Budapest, the viewer's gaze fell on nothing more than a second sheet of blank paper, this time pink (pink rather than red, because Hungary was regarded as the jolliest barracks in the otherwise unrelievedly red Socialist camp) (fig. 2). Or there might be a number of erotic innuendos with which my intention was simply to provoke. To take another example: a square of aluminum foil was cut out and affixed to one of the pages, creating a kind of self-portrait thanks to the resulting mirror image. In later years, gimmicks of this kind, and any number of variants of them, could be seen in the apparently more popular than serious conceptual works among the concrete art and graphics produced in the underground or subcultural circles.

The idea of bringing together conceptual-type works (which the *Five Books* in effect were) in the form of a pamphlet had its origins in the catalog of the exhibition *When Attitudes Become Form.* On a previous study trip to Germany in 1969, I had taken the opportunity to visit Harald Szeemann's legendary exhibition, which had traveled on to the art museum in Krefeld (Haus Lange). I realized that justice could be done to the kind of art on display even without the expensive materials and physical dimensions that were otherwise the norm in the visual arts. The exhibition catalog took the form of a dossier and seemed an artwork in its own right—one that comprised only ideas and plans for the realization of particular concepts. The term *dematerialized art* was already in the air. In the light of these precedents, it was not difficult for me to arrive at an art form for which the modest dimensions of a magazine or booklet sufficed.

Cologne: An Attempt to Perpetuate the *Five Books*

In Cologne, I tried to design a "sixth issue" to supplement the *Five Books,* and this was indeed published, under the title *Identification Program* (1971), in the first year of my stay in Germany, albeit this time it was offset-printed (figs. 3, 4).

In keeping with the new circumstances, however, this attempt resulted in a publication that was different in every respect from the *Five Books* in Hungary. It was all about capturing quite elemental phenomena (such as cloud formations, or the waves on the surface of the water, or human breath, or even finding and holding onto good fortune in the shape of a four-leaf clover). All these motifs were represented photographically and featured the addition of written or stamped-on numbers, an example being the meadow flowers (migratory, like birds in the autumn), which I "ringed," thus rendering them identifiable. I regard this *Identification Program* as far more systematic and serious than the amusing, colorful booklets I produced in Budapest. However, precisely because of this difference from the earlier booklets, they were no match for the handmade *Five Books*. The very title *Identification Program* (and, in it, the word *identification*) suggests something serious and at the same time almost commonplace.

I made one more attempt to continue the *Five Books* in the form of an offset-printed booklet. This issue was titled *Navigation Exercises* and subtitled *Compass with Exchangeable Cardinal Points* (1972, fig. 5). The meaning is encapsulated in the title. The

flowers with an identification-ring
ready for an eventual trip south in autumn

028526 028543 028525

identification of
waves

328547
328549 328548
328550
328550
328551
328552

Géza Perneczky: Navigation exercises

FIG. 3.
Géza Perneczky (German, b. Hungary, 1936).
Flowers with an Identification-Ring.
From Géza Perneczky, *Identification Program*
(1971), n.p.
Los Angeles, Getty Research Institute.

FIG. 4.
Géza Perneczky (German, b. Hungary, 1936).
Identification of Waves.
From Géza Perneczky, *Identification Program*
(1971), n.p.
Los Angeles, Getty Research Institute.

FIG. 5.
Géza Perneczky (German, b. Hungary, 1936).
*Navigation Exercises: Compass with Exchangeable
Cardinal Points* (1972), n.p.
Los Angeles, Getty Research Institute.

booklet, which was printed in black and white, included a cardboard sheet bearing the image of a round compass that could be cut out. What is unusual about this is that the initial letters of the four cardinal points (that is to say, *N, E, W, S*) could be pressed out, rendering them interchangeable. I was only able to sell a few copies of this publication, which had a great deal to say about what it felt like to be a new immigrant in a foreign land. In the meantime, I had more success with some of my other photographs.

Conceptual Photography: *Concepts like Commentary* and *Art Bubbles*
During my first year in Germany, I lived in a former student dormitory that had lapsed into a temporary hostel for occasional transients or younger refugees from the Eastern bloc. Those who frequented it referred to it simply as the Hungarian House (Magyar Ház). In my shared room, I had a bed and half a table, on which I constructed a tiny stage out of squared cards so that I could set up and photograph small-scale art installations. I used a 35 mm Praktica camera (a GDR brand) that I had brought with me from Hungary. Not far from the Hungarian House, I discovered a youth club. Its basement contained a neglected photo lab, where I was able to develop my photographs and make enlarged prints on paper.

I developed a series consisting of small triangular forms with strings attached bearing the words *yes* and *no* (*Yes–No Dialectic,* 1971). One of those to whom the triangles appealed was Helmut Rywelski, head of the art intermedia gallery in Cologne. He had an edition of one hundred produced in hard plastic, and he planned to hold an exhibition of my work in his gallery. Before this could happen, however, Rywelski was forced to file for bankruptcy. The background to this was that art intermedia worked closely with Joseph Beuys and his disciples. Rywelski, an idealist, took seriously Beuys's doctrine and demand that his artworks should be inexpensive and accessible to everyone, and so Rywelski hardly ever sold work for more than ten or twenty marks. People did not want to acquire even a work by Beuys this cheaply, and Rywelski saw his public fall away. Because of this experience, I was able to form an idea of the complex nature of capitalism shortly after my arrival in the West.

In early 1972, I began teaching in a high school (drawing, painting, art history, and art theory) and moved into a room of my own in the city. As it happened, this room had a window with a single, undivided pane of glass. I discovered that I could blow soap bubbles that would reflect the window as a whole, neat square in their upper surface. Now, if I cut some large letters out of black photo-mounting card and attached them to the window, this lettering would be reflected not once but twice (right-side up and upside down) against the bright patch of window on the soap bubbles. Taking advantage of this effect, I produced a final variant of my bubble-based action with the lettering *art* (this time written on the window), bringing to a conclusion my *Concepts like Commentary* series. The word *art* appeared on the bubbles, which would then burst. Before long, this

FIG. 6.
Géza Perneczky (German, b. Hungary, 1936).
The Word Art (left); *Artist Portrait* (right), from the series *Art Bubbles* (1972), scan from negative. Budapest, Collection of the artist.

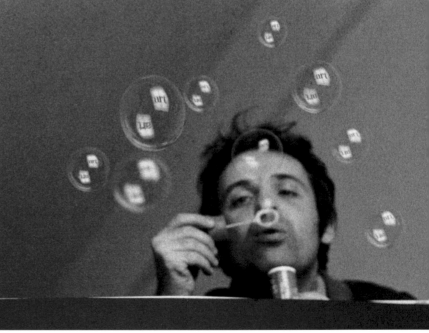

action attained great popularity and remains to this day one of my best-known works: *Art Bubbles* (fig. 6).

Friends from Budapest and Brno Visit Me in Cologne

During these one-and-a-half to two years, I remained in very close contact with the friends I had left behind in Hungary, most of whom were artists of a neo-avant-garde bent. In the years 1970 to 1973, these artists moved their activities to the shores of Lake Balaton, holding exhibitions and actions (particularly during the summer months) in a chapel in Balatonboglár. At that time, this chapel was the only place in the Eastern bloc where young artists, not only from Hungary but also from neighboring countries such as Czechoslovakia and Yugoslavia (now the Czech Republic and Serbia), could come together and take part in the collective events that were held there. In 1970, during the months leading up to my departure for Germany, I used to spend the weekends at this chapel in Balatonboglár.[1]

From 1972 onward, I forged closer friendships with various members of this circle of foreign visitors to Balatonboglár. One of them was Jiri Kocman, who lived in Brno (Czechoslovakia). I was fascinated by Kocman's rubber-stamp art. Our correspondence led to such a close connection between us that when, in the second half of the 1970s, he obtained permission from the Czechoslovakian authorities to visit his sister, who had married and moved to Switzerland, he arranged to travel via Cologne. He brought his rubber stamps with him and gave them to me. Having been the first artist on the international scene to raise stamping—in truth a soulless bureaucratic task—to the rank of an independent artistic genre, Jiri explained that he had now stopped making rubber-stamp art.

I Too Begin to Make Rubber Stamp Art

Kocman adopted this form of expression from the French mail-artist Ben Vautier but developed it into a subtle and sophisticated poetic genre, a miniature form of concrete art. All of his stamps bore short texts, which, on account of their inevitably sparse, compressed form, came across as challenging and thought provoking.

Following his example—not with texts but with small objects that could be found lying around anywhere, and whose meaning could be discerned only with a certain amount of concentrated reflection on the part of the viewer—I produced my first series of rubber-stamp art, which I collected in a portfolio titled *Stamping by Little Objects* (1973, figs. 7, 8). Here, of course, rubber as a material and the term *rubber stamp* are to be understood figuratively, because they took a rather different form than the traditional kind of stamp. Stamps they most definitely were, however, not least because I fitted the various small objects with the usual kind of handle.

This portfolio attracted a great deal of attention. The following year, Michael Leaman of the Verlagsgalerie in Düsseldorf ordered—in an edition of one thousand (!)—a series with new motifs for inclusion in his periodical, which was in reality an assembling, or collection, of artworks presented in a folder and titled *Reaction*.[2] I put together this new portfolio using small components that had dropped out of a television set I had found dumped in a forest. I called it *Silence* (1974).

After this, I continued to produce rubber-stamp art, either in portfolio or some other form, on an annual basis.[3] This activity culminated in, and concluded with, the project *Karl Marx Test* (1983), to which I will return later.

Stille-Stempeln

mit Bestandteilen eines im Wald von Öldorf
(5235 Hommerich) fortgeworfenen Fersehgerätes
(Nordmende, Souverän 58, No. 35975).
Diese Bestandteile eignen sich dazu, die Stille
zu empfangen und durch Stempeln an den Betrachter
weiterzusenden.

Stamping Silence

with parts of a Television (Nordmende, Souverän 58,
No. 35975) thrown away in the Forest of Öldorf
(5236 Hommerich). These parts are conducive to
receiving silence and to send it to the spectator
by stamping.

Perneczky Géza

The Ground Rules of the Network Are Born — and Something about the Network's First Apostle, Ulises Carrión

I also corresponded with a number of Polish artists, including, in around 1971–72, Jaroslaw Kozlowski and his friend Andrzej Kostolowski. They founded an information organ called NET that appeared periodically. This can be regarded as the original form of the later Network (and indeed, ultimately, of the Internet itself!). It consisted of a set of rules and an address list comprising some five hundred artists — network participants from all over the world who were duly invited to contribute. The rules outlined an international network of artists constructed along entirely homogeneous lines (that is to say, it was not allowed to have any central nodes anywhere) that guaranteed unrestricted, free-of-charge access to the works and information in circulation. At the same time, any form of copyright deriving from financial considerations was strictly forbidden within the NET, although authorship of the individual works was recognized. This network was to be open to anyone and was to be susceptible to further development through new ideas and suggestions. The entire plan was typed out and copied using carbon paper. It also contained a list of twenty-six artists (half of them from Eastern Europe) who were to be regarded as founding members. When I received a copy of this manifesto in the mail from Jaroslaw Kozlowski, I discovered my name among the founding members. This was in May 1972.

But there were various other early forms of international contact between artists as well. I made the acquaintance of the Mexican artist Ulises Carrión in 1972. Although a poet, an organizer, and a manager, he was a person for whom the visual experience was of paramount importance. From around 1971, he ran an art gallery in Amsterdam called the In-Out Center. Ulises invited me to take part in an exhibition at the In-Out Center in autumn of 1973, and I showed a selection of my photography-based concepts: *Concepts like Commentary* (1971), *Art Bubbles* (1972), *Mirrors* (1973), and so on.

Ulises published a monthly magazine called *Ephemera* (one of the first magazines in which, alongside conceptual works and visual poetry, examples of mail art also appeared). He wrote, published, traveled, gave lectures, and even, on one occasion, turned up in Budapest, where he put on an exhibition at the Young Artists' Club (Fiatal Müvészek Klubja). He was a true champion of the communication-based art that had become so popular during this period, and also of all kinds of hard-to-define paper-based art.

The Golden Age of Alternative Art Forms in Amsterdam

Ulises Carrión's friend Aart van Barneveld was a Dutchman who worked as the curator of a section of the printing house Posthumus, Amsterdam, that was given over to stamp art. In the second half of the 1970s, Aart turned what was already a gallerylike venue into a unique exhibition space for stamp art called Stempelplaats. I continued to make stamp art for many years and took works of this kind to Amsterdam by the dozen.

The experiences I have outlined here will have already given the reader an idea of how I gradually "slipped" from the lofty status of graduate art historian and — as an artist — from the highly intellectual domain of neo-avant-garde endeavor (more specifically, conceptual art) to a far more spontaneous and more freely organized environment as I became aware of a milieu in which people worked in an utterly free and intuitive manner. As a rule, these individuals were more interesting and also more creative than the moguls of the artists' associations, and, what's more, they were often in possession of far more meaningful information. In these circles, nobody minded being surrounded

FIG. 7.
Géza Perneczky (German, b. Hungary, 1936).
Transistor Radio in Forest, gelatin silver print and typescript, photograph: 24 × 18 cm.
From Géza Perneczky, *Stamping by Little Objects* (1973), n.p.
Los Angeles, Getty Research Institute.

FIG. 8.
Géza Perneczky (German, b. Hungary, 1936).
Little Objects, gelatin silver print and stamp art, photograph: 24 × 18 cm.
From Géza Perneczky, *Stamping by Little Objects* (1973), n.p.
Los Angeles, Getty Research Institute.

by "greenhorns" (such as students), amateurs (such as printing press staff), housewives with a penchant for painting and handicrafts, truck drivers, or the young employees of design or decorating studios. And no one objected to spending time in the colorful world of the subcultures of the day.

I accepted an invitation to take part in a mail-art project for the first time in the 1970s and sent off my work to the advertised address. Over time, I learned how to make all kinds of small items, collages, and highly improvised works of mail art using a type-writer, a Xerox machine, rubber stamps, felt pens, colored pencils, scissors, glue, and a stapler. During the second half of the 1970s, I played an increasing role in the interna-tional activities of the mail-art network. My mailbox was filled with interesting multicol-ored bits of paper that always held great promise. Everything that came into my hands was highly creative and colorfully designed, and I felt happy in this utopia made of paper.

There were periodic high points that were capable of astonishing even one such as me, an observer inhibited by his critical faculty. As I remember, one experience of this kind was an event announced as a mail-art exhibition, but in reality, it was more of a stage-based festival (with installations, performances, actions, and music) that I caught by chance while on a weekend visit to Ulises Carrión in November 1982. In Spuistraat, in the center of Amsterdam, not far from the Royal Palace, stood a large building that had once housed the editorial offices and printing works of a daily newspaper. By this time it had fallen into complete disrepair, and in this dilapidated state it was occupied by squatters who were members of the underground. The window panes were smashed; the wind fluttered the mail-art contributions, which had been submitted in the hundreds, attached to the walls everywhere. The project was called *Artist / World–World / Artist.* It was a unique demonstration, a quasi-artistic manifestation, a presentation of the art of the masses, generated by the mass society that had come into being shortly before, whose pioneers had perhaps been the very same anonymous Networkers and their fol-lowers who were gathered here.

I Become the Author of Many a Network Directory, and, in This, Receive Support from the Network's Most Important Archivists

Similar events and gatherings were to take place by the dozen in the 1980s, that is to say, when mail art was flying high. While trying to keep abreast of what the underground was up to on a daily basis, I carefully collected even the smallest reflexes that had to do with other people's activities or mentalities. This passion for collecting resulted not least in the large tomes *Network Atlas I & II,* which I compiled in the 1990s.[4]

Who Were My Closest Colleagues in the Mail-Art Network?

I maintained contact with many of the protagonists of mail art by letter and even the occasional personal visit: Vittore Baroni, the one-man editorial team of the mail-art mag-azine *Arte Postale!,* in Italy; Leslie Caldera (also known as Creative Thing) of *RANT* pub-lications, who was in Los Angeles, along with Richard Meade of *Data File* magazine and Lon Spiegelman of *Mailarts Rag;* Charles Pittore of *ME* magazine, in New York; Steve Per-kins of *Box of Water,* who lived in San Francisco back then; Anna Banana, of the legendary magazine *VILE,* from Vancouver; Bill Gaglione, who was already running a rubber-stamp factory in his spacious garage in San Francisco; István Kántor (also known as Monty Can-tsin), the founder of Neoism, from Budapest; Mark Pawson, a graphic designer and mail

artist from London; Robin Crozier, a teacher and mail artist also based in England; Günther Ruch, the publisher of *CLINCH;* and Edgardo-Antonio Vigo, a publisher in Argentina.

Penuriousness, Loneliness, and Social Warmth — Behind and in Front of the Iron Curtain

Mine is the story of a young man who arrived in a foreign country, sought out a milieu that suited him, and formed social relationships that not only allowed him to feel to some extent at home but also enabled him to discover new forms of survival and to contribute to the creation of a somewhat complex community in which he was then able to enjoy some social warmth.

The 1970s saw the development of a "highway" for artists between East and West, and specifically between Budapest and Essen, initiated by Dieter Honisch. At some point in the mid-seventies, there was a year when the number of "visitor nights" spent in my apartment reached about 160.

Among these visitors, there were no mail artists until the end of the 1970s, when György Galántai and his young wife, Julia Klaniczay, came to Western Europe on a study trip and also visited Ulises Carrión in Amsterdam. Only then did the pair form an impression of what Network activity meant and how an extensive, continuously growing archive could develop from it. Upon returning to Budapest, they founded the Artpool archive, and in 1979–80, they sent out announcements and invitations to all points of the compass soliciting artistic contributions to Artpool.

By 1971, Endre Tót, who as recently as the 1960s had been an abstract-expressionist painter in Budapest, had already created his circular rubber stamp with the smiling face and heading "I'm glad if I can stamp." This makes him the first mail artist in the world to work with rubber stamps. Back then, he used to travel from Budapest to Belgrade simply to drop his *Zero Correspondence* into the mailbox (had he mailed it in Budapest, it would no doubt have been intercepted by the authorities).[5] This was already mail art, and of the best quality too. Tót collaborated with John Armleder's Ecart Publications in Geneva, and after that spent some time in London. On the brink of world fame, he returned to Budapest, where he was unable to obtain permission to leave the country again until 1978. I met him in Cologne in about 1980, when he settled there.

A less direct influence on his surroundings in Budapest was exerted by Gábor Toth, who came to attention in 1972–73 with his works of visual poetry, before going on to become one of the most significant protagonists on the Budapest scene. Within the Hungarian mail-art scene as a whole, it was probably Robert Swierkiewicz who conformed most closely to the international notion of the mail artist.

Credible-seeming utopias were essential for survival, and for a time mail art was a vehicle capable of transporting such utopias. It was barely more than a positively tinged difference in atmosphere, but even this seemed capable of facilitating a less fraught way of dealing with people. And it enabled us to forget for a while the otherwise so unpleasant pressure of our environs.

The Structure of Mail Art — and the Question of Quality

It was not the privileged elite of a traditionally structured society that found its home in mail art, and neither was it the bourgeois middle class, among which the art of the twentieth century found its audience. Mail art represented a widely scattered diaspora

whose individual members, in some cases, lived several thousand kilometers apart and responded to a particular signal—the announcement of some art project or other. Important here was the role played by modern means of communication: not, at this point in time, the Internet or e-mail networks but postal networks supported by air transport, thanks to which any mailing would reach its destination in thirty-six or, at most, forty-eight hours.

The hard core could be compared to the board of a bank: possessing knowledge concerning the structure of the entity in question and perhaps sending out signals that were not always received. The capital of this "bank"—an amazing aggregation of subjects and ideas, address lists, and contacts (as well as the knowledge of how best to manage them)—was accumulated by the small members of this savings union and reorganized or added to on a daily basis. Good art should not be overly discriminating and should not exclude the vulgar and the everyday from its sources.

How to Show Mail Art—and the Answer to the Question of Quality

After the fall of the Berlin Wall toward the end of 1989, the Eastern European mail-art network also collapsed, because its prime reason for being—that is to say, the pressure from the power structure of a narrow-minded dictatorship—had suddenly disappeared.

Guy Schraenen understood mail art as the product of communication within a subculturelike community that maintained its shape through continuous correspondence. The most important thing was the uninterrupted flow of mailings and the constant exchange of material. It would not be incorrect to see the whole thing as an ongoing series of rituals whose real purpose was to strengthen social ties. (Compare this with the greeting rituals of pairs of birds and so on.)

It follows from this that the most important product of mail art was always the accumulated material of a successful mail-art project! This mass of material could be unexpectedly expressive, and it is this expressivity that determines the meaning and quality of mail-art initiatives. Kees Francke's *The Workers' Paradise* (1986), for example, which alluded to the ideological turns of phrase customary in Eastern bloc countries and to Marxist-Leninist doctrine, was shown in East Berlin and Dresden to start with, but subsequently in Warsaw, Kraków, and Wrocław (illegally!) as well.

The Most Important Types and Manifestations of Mail Art

These artifacts offered up for exchange represent a desire for contact, but they were also the products of human creativity. And they were motivated by the attempt to find an audience among one's addressees. This demonstrates how mail art acted as a safety valve through which the creativity that had built up in the subcultures was released into the open. What participants would find in their mailboxes was therefore always unpredictable. From my own experience, I can attest that the envelopes were invariably worked in some way by the sender and were often—in addition to the usual franking—thickly pasted with self-made stamps or stamps borrowed from other artists. Furthermore, these additions were meant to correspond to the characteristic visual form of an envelope. This resulted in the practice of including in a mail-art archive not only the contents but also the packaging of a consignment.

The most valuable objects among the individually executed works were, of course, the catalogs of mail-art projects—generally compiled by hand and then photocopied,

although sometimes offset-printed—and the amateurishly edited but from time to time exceptionally beautiful magazines, which were either compiled from Network documents or dedicated more to graphic work and contributions of visual literature; sometimes they assumed a fabulously colorful guise thanks to the combination of all kinds of things stuck to the pages in a sort of collage. The idea behind these publications was that the end result should radiate joy.

An unsurpassable example of this joy—a euphoric embracing of the world for which only mail art had sufficiently long arms and sufficiently bold utopian visions—was Ryosuke Cohen's *Brain Cell* (started in 1985 and still going), a single-sheet A3-format periodical that effectively collects and redistributes stamps, stickers, and graphic material.

Exponents of the Traditional Avant-Garde and the New Complexity in Mail Art

In the countries of Eastern Europe—where the various subcultures developed more slowly (due to a general backwardness), and where highbrow culture and its institutions, inherited from previous times, played a larger role than elsewhere and served to inhibit new ideas—artists with academic training played a noticeably more significant role in the development of experimental art movements, mail art included.

Two artists who represented the beginning and the end—Robert Rehfeldt, for his style, and Guillermo Deisler, for his formal language—employed the collage technique that was a legacy of Dada and the calligraphic script of the earlier (and in part Eastern European) constructivism to signal protest and their unbroken life force.[6] Deisler edited an assembling magazine in typical samizdat style and was sent material for it from all over the world. This magazine was called *UNI/vers* and was the swan song not only of mail art in the GDR but of the classic epoch of the entire culturally oriented underground movement in Europe.

Pawel Petasz was the only one of the outstanding initiators of mail art who acted in an entirely instinctive, anti-intellectual, and anarchic manner, creating works of great intensity that came across as extremely uncompromising and subversive. It was also he, however, who proposed the highest form of rationally designed complexity and communications logistics within the Network. His magazine, *Commonpress,* was in a class of its own as far as assemblings were concerned. At this time, "assembling magazines" were periodicals with a specific number of pages, each of which was supposed to be a signed original work. Within the Network, there were eighty such magazines with varied titles. Petasz began publishing an assembling magazine in Poland in 1977, and the *Commonpress* network developed into an abstract model of himself and his own complexity. Each issue was edited by a different Networker, a task that revolved carousel-like throughout the entire Network.[7] This was also a kind of ritual that helped to ensure the cohesion of mail art, which was otherwise scattered across the diaspora.

My Mail Art Project *Karl Marx Test* (1983)

My Marx project was actually edited not by me but by the entire Network. The starting point for the whole thing was the centennial anniversary of Karl Marx's death in 1983 and the corresponding commemorative festivities held in Arnhem, the Netherlands.

One of the various events organized was a mail-art show. This time, the exhibition venue was the foyer of a theaterlike multipurpose building called the Showburg. I was invited to take part in this *Marx Now* exhibition, along with many other mail artists whose

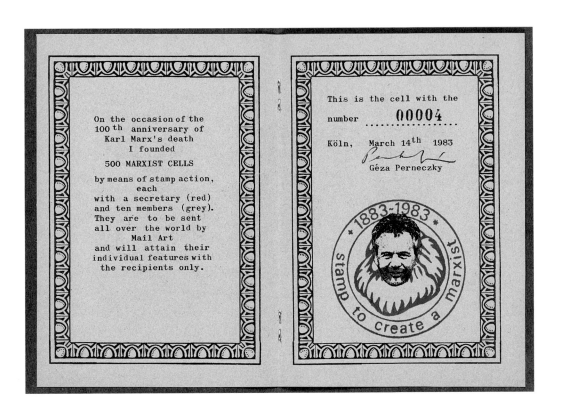

On the occasion of the 100th anniversary of Karl Marx's death I founded

500 MARXIST CELLS

by means of stamp action, each with a secretary (red) and ten members (grey). They are to be sent all over the world by Mail Art and will attain their individual features with the recipients only.

This is the cell with the number 00004

Köln, March 14th 1983

Géza Perneczky

30

Birger Jesch (GDR)
Ko de Jonge (NL)
Robert Rockola (USA)

Montserat C. Bacaria (E) Fragment
Guy Bleus (B) Fragment
Mogen Otto Nielsen (DK) Fragment

27

Stephan Missmahl (D)
Mogens Otto Nielsen (DK)
Sjoerd Paridean (B)
John Slattery (UK)

Henning Mittendorf (D)
Jürgen O. Olbrich (D)
Carlo Pittore (Ch. Stanley) (USA)
Klaus Staeck (D)

S. J. Nakamara (Beethoven) (J)
Open Head Arts (GR)
Günther Ruch (CH)
Joachim Stange (GDR)

names were to be found on the usual address lists. I came up with a relatively large picture of three Marxes based on the well-known model of the three monkeys: see no evil, hear no evil, speak no evil.

A week later, it struck me that I could maybe do something better for the Karl Marx anniversary. I therefore created five hundred small booklets along the lines of the party membership cards and called them *500 Marxist Cells* (fig. 9). In each of these little books, it was stated that these party cells were being founded by me, Perneczky, and that they should be used in any way the recipients saw fit. I then ordered from an office stationery supplier a rubber stamp depicting Marx's characteristic hirsute head, but with his facial area left blank, so that the recipients could paint or draw their own features into this part of the stamp. The circular stamp was also given a title: *1883–1983 stamp to create a marxist.* Using this stamp, I then created five hundred of the little books, each containing eleven pages, with a Marx head stamped in red for the party secretary of the cell, and ten images stamped in gray for the regular members. I stapled the pages into the covers and, without any further explanation, immediately sent out two hundred or so of the finished brochures to various mail-art partners on my address list.

After about a week, I noticed that the booklets' inserted pages were being returned to me—one by one to start with, but before long they began streaming back in the mail by the dozens. This amounted to a sublime inventory of all that Karl Marx was able to tease out of my contemporaries. I had to sit down at the table again and somehow create a catalog of this mail-art project that was unintentional but had materialized nonetheless (figs. 10, 11).

It was a success.[8] More than ten years after leaving my native country, I had finally arrived in the West. **X**

FIG. 9.
Géza Perneczky (German, b. Hungary, 1936).
500 Marxist Cells, from the series *Karl Marx Test* [1983] (Cologne: Soft Geometry, 2010). Los Angeles, Getty Research Institute.

FIG. 10.
Géza Perneczky (German, b. Hungary, 1936).
Artist stamps and envelopes, from the series *Karl Marx Test* [1983] (Cologne: Soft Geometry, 2010). Los Angeles, Getty Research Institute.

FIG. 11.
Géza Perneczky (German, b. Hungary, 1936).
Artistic interventions, from the series *Karl Marx Test* [1983] (Cologne: Soft Geometry, 2010). Los Angeles, Getty Research Institute.

NOTES

This essay was translated from German by Richard George Elliott. It was shortened for publication.

1 In the summer of 1973, this oasis of artistic freedom was violently occupied and shut down by the authorities. (The closure of the chapel is mentioned in Poggi and Cuevas-Wolf, this volume.)

2 *Reaction* was an annual periodical that brought together original works created within the context of Fluxus and concrete art. It continued into the 1980s.

3 *Spirit Stamping* (portfolio and postcard series), 1975; *Memory,* 1977; *Stamping in Italy,* 1978; *Night Stamps*/photo technic, 1979; *Stamping Bird Twittering,* 1980; *International Stamps I (Secret)* (booklet and postcard series), 1980; *International Stamps II (Merde),* 1981; *Very Alternative Art / Merde* (on toilet paper), 1981; *Albino,* 1981; *Post Infinite,* 1982; *Breakage,* 1982; *Isolated,* 1982; *Pseudo Computer,* 1984; *The Secret Life of the Cologne Cathedral,* 1984, etc.

4 See "Atlas — Mail Art," website of Géza Perneczky, www.c3.hu/~perneczky/atlas.html.

5 Part of Endre Tót's activities in the 1970s consisted of writing letters and telegrams that contained only zeros (for example, "0000 00 0000000 0 00, 000!") and sending them out by mail. This work was referred to collectively as the *Zero Correspondence.*

6 Both were connected to other exponents of Eastern European mail art, in particular Piotr Rypson (the magazine *Sator Comix*) and those anomalies in the Russian underground, Rea Nikonova and her husband, Serge Segay, who were influenced by the Russian tradition of zaum literature, which was a strong presence in their work.

7 Each individual issue was to be compiled by a different Networker. Not only was the underlying theme of the next number announced in the current issue, so too were the names of the changing editors.

8 Word got around in mail-art circles that I was possibly the only art historian among the Networkers. Add to that the fact that I was known to be a passionate archivist, and it was suggested by my friends as early as the 1980s that I should publish the material I had collected. My most important publications are as follows:

 The Magazine Network: The Trends of Alternative Art in the Light of Their Periodicals 1968–1988 (Cologne: Soft Geometry, 1993).

 Network Atlas: Works and Publications by the People of the First Network, A Historical Atlas for the Post-Fluxus Movements as Mail Art, Visual Poetry, Copy Art, Stamp Art & Other Relative Trends with Addresses, Projects, Publications & Exhibition Events, 2 vols. (unedited manuscript) (Cologne: Soft Geometry, 2003).

 Vol. 1, A–N: http://www.c3.hu/~perneczky/mail.art/Atlas/Letter_S/LAtlas_1.pdf.
 Vol. 2, O–Z: http://www.c3.hu/~perneczky/mail.art/Atlas/Letter_S/LAtlas_2.pdf.

 The Soft Geometry Archives, vol. 1, *Correspondence Works and Labels* (second version of the unedited manuscript) (Cologne, 2003):

 http://www.c3.hu/~perneczky/mail.art/Cor_book/Corr_B_1.pdf
 http://www.c3.hu/~perneczky/mail.art/Cor_book/Corr_B_2.pdf
 http://www.c3.hu/~perneczky/mail.art/Cor_book/Corr_B_3.pdf
 http://www.c3.hu/~perneczky/mail.art/Cor_book/Corr_B_4.pdf
 http://www.c3.hu/~perneczky/mail.art/Cor_book/Corr_B_5.pdf

 Assembling Magazines 1969–2000 (Budapest: Árnyékkötök Foundation, 2007).

 Mail Art Project: Marx Test, 1983 (Cologne: Soft Geometry, 2010). This is a facsimile edition of a photocopied brochure from the year 1983. The original German text of the essay (the second part in this publication) is a revised draft complete with color images.

 The Soft Geometry Archives, vol. 2, *Corresponded Works: Experimental and Marginal Art* (Cologne: Soft Geometry, 2010).

ACKNOWLEDGMENTS

Many people helped us to realize this exhibition and book project on Cold War Hungary over the last four years. We would like to thank, foremost, our two institutions, the Getty Research Institute (GRI) and The Wende Museum of the Cold War, for their support and encouragement in this collaborative initiative. In particular, we would like to thank the GRI for hosting our workshop "Photography and the Visual Arts in Cold War Hungary" in July 2015 and GRI Publications for publishing this book.

Our project benefited from the constructive criticism of Joes Segal and Donna Stein at The Wende Museum; David Crowley, Krisztina Fehérváry, Colin Ford, Éva Forgács, and Beverly James, who participated in the GRI workshop; and Martina Winkler and the participants at the international conference "Picturing Power: Photography in Socialist Societies" at the Universität Bremen in 2015. Above all, the coeditors would like to thank Frances Terpak for her constant and generous assistance and advice throughout the writing of this book and the development of the exhibition.

We are indebted to the many archives and collections in Budapest, Hungary: Artpool Art Research Center; the Hungarian National Gallery (Magyar Nemzeti Galéria); the Hungarian National Museum (Magyar Nemzeti Múzeum); Ludwig Museum Budapest—Museum of Contemporary Art (Ludwig Múzeum Budapest—Kortárs Művészeti Múzeum); the Vera and Donald Blinken Open Society Archives at Central European University (CEU); and Fortepan. We are very grateful to the Universität Bremen Weserburg Zentrum für Künstlerpublikationen and the Forschungsstelle Osteuropa. We are thankful to many colleagues for sharing their extensive and invaluable firsthand knowledge of the period: Barnabás Bencsik, Katalin Bognár, Katalin Cseh-Varga, Dávid Fehér, Péter Forgács, György Galántai, Gyula Gazdag, Zanna Gilbert, Ksenya Gurshtein, Dóra Halasi, Ágnes Háy, Peter Hay, Judit Hegedüs, Sándor Hornyik, Péter Horváth, Aniko Katona, Károly Kincses, Eszter Kiss, Julia Klaniczay, Péter Korniss, László Lakner, József Mélyi, András Mink, Kristóf Nagy, Géza Perneczky, Zsolt Petrányi, Sándor Pinczehelyi, Attila Pőcze, Viktória Popovics, László Rajk, István Rév, Michael Simon, Mark Snowiss, Erika Sólyom, Lóránt Szabó, Katalin Székely, Csaba Szilágyi, Lenke Szilágyi, Thomas Szlukovenyi, Anelia Tuu, Ádám Urbán, Tibor Valuch, Tibor Várnagy, János Vető, and István Virágvölgyi.

We want to thank The Wende Museum's staff for their collaboration, as well as Judith Hoffman and Máté Gergely Balogh for their help with translations; the staff of GRI Cataloging, Curatorial, Conservation, Digital Services, Exhibitions, Library Services, the Registrar's Office, and Special Collections for their assistance; Linda Marie Conze, curatorial research fellow of the Alfred Krupp von Bohlen und Halbach-Stiftung; Árpád Kovacs at the J. Paul Getty Museum; Christina Peter; and Marjorie Ornston for her dedication and commitment to the project from its inception.

— Cristina Cuevas-Wolf and Isotta Poggi

CONTRIBUTORS

Katalin Cseh-Varga is a lecturer in the Department of Theatre, Film, and Media Studies at the Universität Wien in Austria and a postdoc at the Graduate School for East and Southeast European Studies at the Ludwig-Maximilians-Universität in Munich, Germany. Her research focuses on the theory of public spheres in the former Eastern bloc, archival theory, creative practices of Hungarian samizdat, and performative and medial spaces of the Hungarian experimental art scene from the late 1960s to the early 1990s. Cseh-Varga's publications include "Innovative Practices of Hungarian Samizdat: A Comparative Analysis of Oral Traditions," in *Zeitschrift für Ostmitteleuropa-Forschung* (2016), and "Performative Interactions with the Past: Re-Conceptualizing Archives and Forgetting in Post-Socialist Context," in *Stedelijk Studies* (2016).

Cristina Cuevas-Wolf is the resident historian at The Wende Museum of the Cold War. She is an art historian and writer on modern German and Eastern European art and photography and has held positions at the Getty Research Institute and the Los Angeles County Museum of Art. Cuevas-Wolf has published work in *Elective Affinities: Testing Word and Image Relationships* (2009); *New German Critique* (2009); *The Worker-Photography Movement, 1926–1939: Essays and Documents* (2011); and *Visual Resources* (2014). She coedited the special issue "East German Material Culture and the Power of Memory" of the German *Historical Institute Bulletin* (2011). Her most recent essay, "The Montage Connection between László Lakner and John Heartfield: The Legacy of a System-Critical Leftist Visual Language," in *Oxford Handbook on Communist Visual Cultures* is forthcoming.

Dávid Fehér is an associate curator in the Department of Art after 1800 at the Museum of Fine Arts (Szépművészeti Múzeum), Budapest, a lecturer at the University of Fine Arts (Magyar Képzőművészeti Egyetem) in Budapest, and a PhD candidate in the Department of Art History at Eötvös Loránd University. His work on photorealism and the transformations of pop art in Hungary and Eastern Europe has been published in *East of Eden: Versions of Reality* (2011) and *International Pop* (2015), as well as in major Hungarian journals such as *Élet és Irodalom, Balkon, Artmagazin,* and *Műértő.* Fehér curated the exhibition *László Lakner: Seamstresses Listen to Hitler's Speech* (2011) at the Szépművészeti Múzeum, and in 2013–14, he was a Deutscher Akademischer Austauschdienst (DAAD) fellow at the Freie Universität Berlin.

Steven Mansbach is a Distinguished University Professor and a professor of the history of twentieth-century art at the University of Maryland. His research and teaching interests focus on the genesis and reception of "classical" modern art, roughly from the last quarter of the nineteenth century to the middle of the twentieth. His publications include *Standing in the Tempest: Painters of the Hungarian Avant-Garde, 1908–1930* (1991); *Modern Art in Eastern Europe: From the Baltic to the Balkans, ca. 1890–1939* (2001); *Graphic Modernism: From the Baltic to the Balkans, 1910–1935* (2007); and *Riga's Capital Modernism* (2013). In addition to holding fellowships and university professorships in the United States, Europe, and Africa, he served for almost a decade as associate dean of the Center for Advanced Study in the Visual Arts at the National Gallery of Art in

Washington, D.C., and as the founding dean and director of the American Academy in Berlin.

Géza Perneczky is a Hungarian art historian, writer, artist, curator, and teacher who has been living in Cologne, Germany, since the end of 1970. He was an eyewitness to the artistic developments in the twentieth century that served as a bridge between the Hungarian and international art scenes. Perneczky contributed to the state-supported daily newspaper *Magyar Nemzet* between 1966 and 1968; to the cultural weekly newspaper *Élet és Irodalom* between 1968 and 1970; and to the art and cultural programming for Hungarian Television about the tolerated progressive art scene. Even before leaving Hungary, Perneczky had been working as a conceptual artist; and after his emigration, he became a key proponent of mail-art stamps in the early 1970s.

Isotta Poggi is the assistant curator of photographs at the Getty Research Institute in Los Angeles, where she works on research, acquisitions, and exhibitions of rare photographs, with a focus on the documentation of cultural heritage, history, and archaeology. She curated the exhibition *Inside Out: Pompeian Interiors Exposed* (2012) at the Italian Cultural Institute, Los Angeles, and cocurated the exhibition *Connecting Seas: A Visual History of Discoveries and Encounters* (2013) at the Getty Research Institute.

Tibor Valuch is a professor of history at the Eszterházy Károly University in Eger, Hungary, and a research chair at the Hungarian Academy of Sciences Centre for Social Sciences (Magyar Tudományos Akadémia Társadalomtudományi Kutatóközpont). His research focuses on Hungarian social and cultural history. He was a senior fellow at the Institute for Advanced Study at Central European University in 2016. Valuch is a prolific author, and his research has been supported by prestigious grants and scholarships from the DAAD (Deutscher Akademischer Austauschdienst), the Erasmus Fund, and George Soros's Open Society Foundation, among others.

ILLUSTRATION CREDITS

Photographs of items in the holdings of the Research Library at the Getty Research Institute (GRI) are courtesy of the GRI. The following sources have granted additional permission to reproduce illustrations in this book:

Page ii. Image courtesy of The Wende Museum of the Cold War, Culver City, 2011.814.042.
Page iv. © György Stalter. GRI, 86-S1431.

Mansbach
Page viii. © Géza Perneczky. Courtesy Chimera-Project Gallery, Budapest.
Figs. 1, 2. Szépművészeti Múzeum / Museum of Fine Arts, Budapest.
Fig. 3. © 2017 Artists Rights Society (ARS), New York / HUNGART, Budapest.
Fig. 4. © 2017 Artists Rights Society (ARS), New York / HUNGART, Budapest. Image courtesy of Hoover Institution Archives, Stanford, California, Poster collection, Poster HU 441.6 R.
Fig. 5. Printed with the permission of Petőfi Literary Museum, Kassák Museum. GRI, 2011.M.8.
Fig. 6. © Estate of László Moholy-Nagy / Artists Rights Society (ARS), New York. Image courtesy of J. Paul Getty Museum, Los Angeles, Department of Photography, 84.XM.231.1.
Fig. 7. © Estate of László Moholy-Nagy / Artists Rights Society (ARS), New York. Image courtesy of J. Paul Getty Museum, Los Angeles, Department of Photography, 84.XM.231.4.
Fig. 8. GRI, 94-S438.

Poggi
Figs. 1, 2. © Erich Lessing. GRI, 2016.R.17.
Fig. 3. © Zoltán Váli. Image courtesy of The Wende Museum of the Cold War, Culver City, 2011.814.015.
Fig. 4. © László Rajk. GRI, 41–647.
Fig. 5. Courtesy of Ágnes Háy. GRI, 2017-B55.
Fig. 6. Tibor Philipp personal papers, Vera and Donald Blinken Open Society Archives, Central European University, Budapest, HU OSA 362.
Fig. 7. © Péter Forgács. József Szilas 8mm/ PPFA Bp.coll.
Fig. 8. © Gábor Kerekes Archive. GRI, 2011.M.8.

Cuevas-Wolf
Fig. 1. Courtesy of Márta Czene. Image courtesy of The Wende Museum of the Cold War, Culver City, 2011.203.017.
Fig. 2. Used by permission of Galéria Lénia. Image courtesy of The Wende Museum of the Cold War, Culver City, 2011.203.010.
Fig. 3. Used by permission of Galéria Lénia. Image courtesy of The Wende Museum of the Cold War, Culver City, 2013.883.116.
Fig. 4. © Péter Horváth. GRI, 2011.M.8.
Fig. 5. Image courtesy of The Wende Museum of the Cold War, Culver City, 2014.017.047.
Fig. 6. © Lajos Görög. Image courtesy of The Wende Museum of the Cold War, Culver City, 2013.931.002.
Fig. 7. © Estate of Árpád Darvas. Image courtesy of The Wende Museum of the Cold War, Culver City, 2014.379.001A.
Fig. 8. Art © László Lakner. Photo courtesy of The Wende Museum of the Cold War, Culver City, 2015.073.001.
Fig. 9. © Tibor Zala. Photo courtesy of The Wende Museum of the Cold War, Culver City, 2010.2013.012.
Figs. 10, 11. Art © The Estate of Gábor Attalai, courtesy of Vintage Galéria, Budapest.
Fig. 12. Courtesy of Antal Jokesz and Vintage Galéria, Budapest. GRI, 2011.M.8.
Fig. 13. Art used by permission of Galéria Lénia. Photo courtesy of The Wende Museum of the Cold War, Culver City, 2013.883.073.
Fig. 14. © Péter Korniss. GRI, 2011.M.8.
Fig. 15. Courtesy of László Beke.
Fig. 16. © Sándor Pinczehelyi.
Fig. 17. Art © Sándor Pinczehelyi. Photo courtesy of The Wende Museum of the Cold War, Culver City, 2012.1286.019.

Fehér
Figs. 1, 2. Art © The Estate of Gábor Attalai, courtesy of Vintage Galéria, Budapest. GRI, 2011.M.10.
Figs. 3, 7. © György & Daniel Erdély, sons of the artist.
Fig. 4. Art © László Lakner. Photo by György Gadányi.
Fig. 5. Courtesy of László Lakner.
Fig. 6. © György Kemény. Courtesy of the artist.

Valuch
Fig. 1. Photo: FORTEPAN 15766 / MHSZ (Magyar Honvédelmi Szövetség, Hungarian National Defense Association).
Fig. 2. Photo: FORTEPAN 41717 / Lechner Office Documentation Center.
Fig. 3. © Péter Korniss.
Fig. 4. Photo: FORTEPAN 4340 / Tibor Kádas.
Fig. 5. Photo: FORTEPAN 66810 / Magyar Rendőr.
Fig. 6. Photo: FORTEPAN 12827 / Kiskos Vajk.

Cseh-Varga
Figs. 1, 4, 5, 6, 7. © The Estate of Gábor Attalai, courtesy of Vintage Galéria, Budapest.
Figs. 2, 3. Photos: György Galántai, courtesy of Artpool Art Research Center, Budapest.

Perneczky
Figs. 1, 2. © Géza Perneczky. GRI, 93-B12135.
Figs. 3, 4. © Géza Perneczky. GRI, 94-B16103.
Fig. 5. © Géza Perneczky. GRI, 94-B16105.
Fig. 6. © Géza Perneczky. Courtesy Chimera-Project Gallery, Budapest.
Figs. 7, 8. © Géza Perneczky. GRI, 94-B16329.
Figs. 9, 10, 11. © Géza Perneczky. GRI, 2893-802.

INDEX

The Getty Research Institute Publications Program
Thomas W. Gaehtgens, *Director, Getty Research Institute*
Gail Feigenbaum, *Associate Director*

© 2018 J. Paul Getty Trust
Published by the Getty Research Institute, Los Angeles
Getty Publications
1200 Getty Center Drive, Suite 500
Los Angeles, California 90049-1682
www.getty.edu/publications

Lauren Edson, *Manuscript Editor*
Catherine Lorenz, *Designer*
Michelle Woo Deemer, *Production Coordinator*

This book is published on the occasion of the exhibition
Promote, Tolerate, Ban: Art and Culture in Cold War Hungary,
held at The Wende Museum of the Cold War, Culver City,
California, from 20 May to 26 August 2018.

Distributed in the United States and Canada by the
University of Chicago Press
Distributed outside the United States and Canada by
Yale University Press, London

Printed in China

Type composed in Norwester and Ideal Sans

Library of Congress Cataloging-in-Publication Data

Names: Cuevas-Wolf, Cristina, editor. | Poggi, Isotta, editor. | Getty
 Research Institute, issuing body.
Title: Promote, tolerate, ban : art and culture in Cold War Hungary / edited
 by Cristina Cuevas-Wolf and Isotta Poggi.
Description: Los Angeles : Getty Research Institute, [2018] | Includes
 bibliographical references and index.
Identifiers: LCCN 2017038510 | ISBN 9781606065396
Subjects: LCSH: Art, Hungarian—20th century. | Art—Political
 aspects—Hungary—History—20th century. | Socialism and art—
 Hungary. |
 Art and state—Hungary—History—20th century. | Hungary—Cultural
 policy—History—20th century. | Hungary—Politics and
 government—1945-1989.
Classification: LCC N6820 .P765 2018 | DDC 700.9439—dc23
LC record available at https://lccn.loc.gov/2017038510

FRONT COVER: Sándor Pinczehelyi (Hungarian, b. 1946), *Sickle and
 Hammer I*, 1973, photograph, 25.4 x 20.2 cm. Photo by Katalin
 Nádor. Los Angeles, Getty Research Institute. See p. 50, fig. 16.
BACK COVER: Miklós Erdély (Hungarian, 1928–86), *The Price of the Willow*
 (*Fecske cigarettes*), 1978, photogram, 20.8 × 29.8 cm. Budapest,
 Collection of György and Daniel Erdély. See p. 67, fig. 7.
PAGE II: Bust of Lenin, 1983, Zsolnay eosin glazed porcelain, height: 26 cm.
 Culver City, The Wende Museum of the Cold War. Artist unknown.
PAGE IV: György Stalter (Hungarian, b. 1956), *Waiting (Várakozás)*, contact
 sheet, 15.5 × 18.9 cm. Los Angeles, Getty Research Institute.